Basic Guide to CREATIVE DARKROOM TECHNIQUES

Executive Editor: Rick Bailey
Editorial Director: Theodore DiSante
Art Director: Don Burton

Notice: This material was first published in the magazine You and Your Camera, published in England by Eaglemoss Publications, Limited. It has been adapted and re-edited for North America by HPBooks. The information contained in this book is true and complete to the best of our knowledge. All recommendations are made without any guarantees on the part of Eaglemoss Publications Limited or HPBooks. The publishers disclaim all liability incurred in connection with the use of this information.

Published by H.P. Books, P.O. Box 5367, Tucson, AZ 85703 602/888-2150
ISBN O-89586-197-6 Library of Congress Catalog No. 82-82769
© 1982 Fisher Publishing, Inc.

©1982 Eaglemoss Publications Ltd., 7 Cromwell Road, London SW7 2HR England

Basic Guide to CREATIVE DARKROOM TECHNIQUES

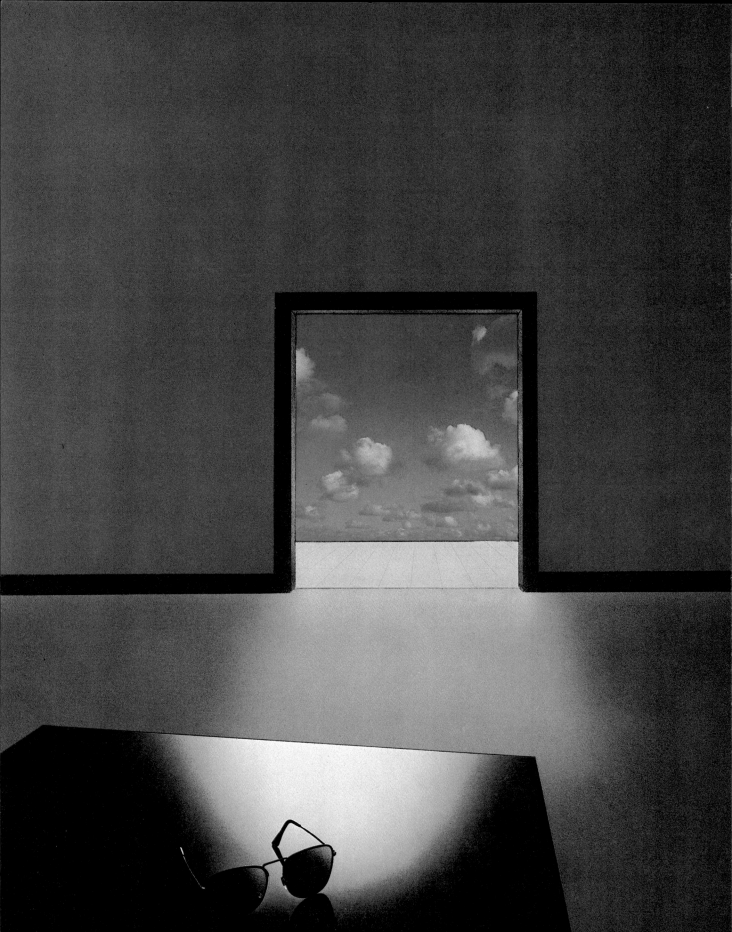

Contents

B&W Photograms

You can make a photographic print without a negative. Working under safelight in the darkroom, you can place objects directly on a sheet of printing paper and expose the paper to white light. After you process the paper, the resulting print—called a *photogram*—shows white silhouettes of opaque objects against a black or gray background.

MATERIALS

You'll need a normal darkroom setup plus some carefully selected small objects with interesting shapes. They can be opaque, translucent or even transparent.

Which objects you select and how you use them depends mainly on your imagination. From experimentation, and the example photos shown here, you'll soon learn what effects various objects will produce.

You can use any type of printing paper to make photograms. Out-of-date paper, which is available at bargain prices at many camera stores, is often adequate. The safelight you use for normal b&w printing will

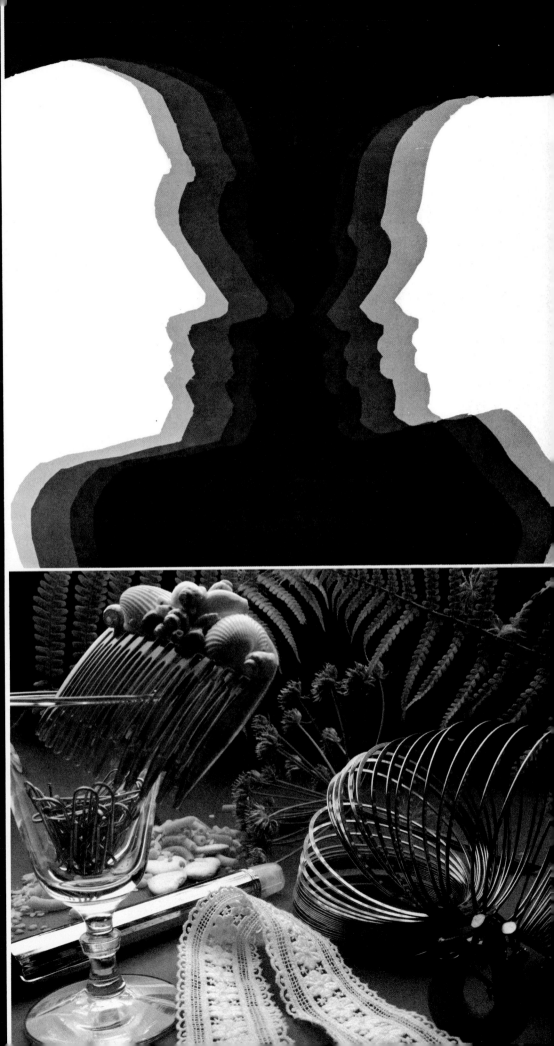

▶ For this photogram, two profiles were cut from black cardboard. They were placed on the paper as masks—first close together for a 10-second exposure, then moved apart in three stages. At each stage, a three-second exposure was given. The resultant gray tones give an impression of depth.

◀ Eggs and hands are good photogram objects because their shapes are graphic and easy to recognize.

▶ You can use a variety of objects like these to make a photogram. A small penlight is useful as an additional light source.

work just as well for making photograms. Use ordinary paper-processing chemicals.

Three suitable light sources are your enlarger lamp, the darkroom's "white" light and a flashlight.

BASIC PROCEDURE

With all of your materials at hand, the room lights off and the safelight on, place your objects directly on a sheet of printing paper. Arrange them in a way you feel will give the best graphic effect. Then expose the paper and process it.

Exposure—Set the enlarger head at a height that gives even illumination over an area somewhat larger than the printing paper. The light does not need to be focused. Set the lens to a midrange aperture, such as *f*-8. Make an exposure test strip by blocking the light to the printing paper with a piece of cardboard held above the objects on the paper.

After you process the print, judge the minimum exposure time to produce maximum black on the paper. Also determine how much exposure you need to produce various gray tones. For future reference, mark the enlarger head's position on the support column, and write down exposure details.

If you want to move the subject during exposure, you need a long exposure time. Set the enlarger head at its highest position and stop the lens down to a small aperture, such as *f*-22.

If you're using the overhead room light or a flashlight as the exposing light source, time your test-strip exposures with a watch or clock.

GRAY TONES

In addition to black and white, you can add a variety of gray tones to your photograms. You can do this by moving an opaque object slightly and giving another brief exposure to produce a gray shade where the paper was previously covered. Or, you can use translucent objects, such as a glass ashtray, textured glass, marbles, cellophane wrapping, light bulbs or net curtains.

Of course, you can also control the background tone with exposure. For a gray tone, expose the paper for less time than required to produce a maximum black. Your test strip will indicate useful settings.

ANGLED LIGHT SOURCE

Instead of using the enlarger or overhead room light for exposure, you can shine a flashlight at an oblique angle to the paper. This method is especially effective

▶ For this print, glass perfume bottles were on the paper. The exposure was made by briefly shining a flashlight from an oblique angle.

▼ Translucent objects such as glasses, bottles, marbles and plastic boxes yield unusual effects when exposed by a penlight or flashlight. Experiment with different lighting angles, distances and exposure times for a variety of effects.

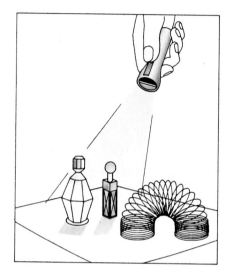

with translucent objects such as small glass bottles. The resulting shape of the object on paper can be distorted in many interesting ways. Experiment with illuminating angles and exposure times.

If the flashlight is too bright or its beam too wide, you can tape pieces of cardboard or red cellophane tape over part of the flashlight glass. You can even use a small penlight to squiggle a free-hand sketch on the paper.

PROJECTION PHOTOGRAMS

You can place suitable small objects on a glass negative carrier and project them on the paper like a normal negative. Best objects are delicate or finely structured feathers, lace, insects, thin sections of vegetables, and leaves. You'll get enlarged photograms with lots of interesting detail. You can find advanced variations of this technique on pages 44 to 47.

PHOTOGRAM VARIATIONS

You can combine soft- and hard-edged images in one print. Simply place some objects directly on the paper, and others on a sheet of glass held above the paper. The farther the object is from the paper, the softer its outline.

An interesting variation is the combination photograph and photogram. For example, you can place a negative of a scene with bushes and trees in the negative carrier, and project them for normal enlargement. Before making the exposure, arrange skeleton leaves and dried grasses on the paper. Expose the combination normally.

There are countless variations to photograms, limited only by your imagination. As you experiment, you'll learn what works and what doesn't, and you'll keep getting new ideas. Keep your photograms simple at first. You'll also find that it's best to plan in advance what you want to do.

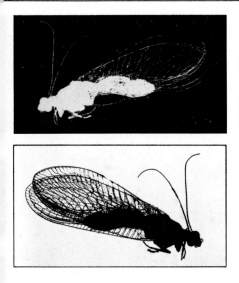

▲ A lacewing was placed directly on the glass negative carrier. Its image was projected onto printing paper to produce a paper negative (top). This was then contact printed to get the positive image.

▲ Right: You can make many designs from a supply of common items, such as the tacks, lentils, rice, pins, paper clips and washers used here.

▶ This looks like an abstract photo of a potter working his wheel, but it's really a photogram of a spring toy called *Slinky*. It was held so it swung halfway between the enlarger lens and the paper during exposure.

▶ The Slinky spring (inset photo) is a pleasing three-dimensional shape for making high-contrast photograms. Here it was placed on the paper. The center portion of the spring was allowed to fall to one side.

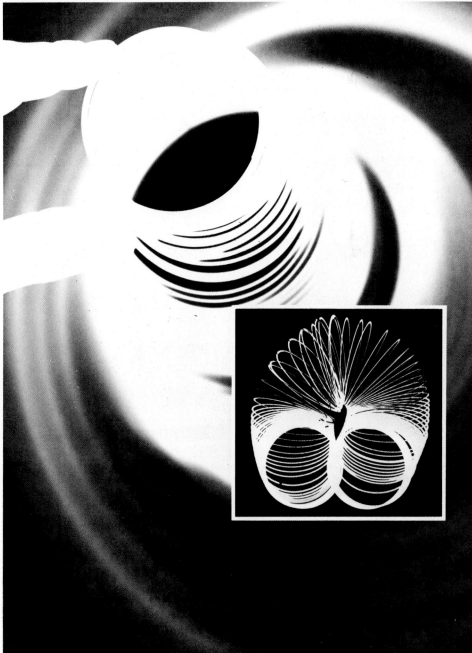

Color Photograms

The basic techniques described for b&w photograms also apply to color—with the extra challenge of creative color control. A good eye for color and design is as important as technical ability.

MATERIALS

You'll need a normal darkroom setup for color printing, plus a thick sheet of glass with smooth edges. Choose some suitable translucent objects to record.

For additional creative scope, you'll need a penlight, some thin cardboard for masks, and a set of "tri-color" filters, such as Kodak Wratten filters No. 25 red, No. 58 green and No. 47 blue.

COLOR PAPERS

For photograms in realistic colors, use a color reversal paper, such as Kodak Ektachrome 2203 or Ilford Cibachrome print materials.

To produce really unusual effects, use a color negative paper, such as Kodak Ektacolor 74 or Unicolor RB. The color in these images will be reversed—complementary to the true colors. For example, a green object reproduces magenta.

Precise color balance is generally not important in photograms. So this is a good opportunity to use up outdated color paper and processing solutions that are still usable but not good enough for normal enlarging.

CHOOSING SUITABLE OBJECTS

Photogram objects fall into three general groups—natural objects, such as leaves, flowers and foods; created scenes, such as photogram landscapes; and abstract patterns.

Remember that you'll be working in color, so look for colorful translucent items such as marbles, plastics and leaves. Leaves and small flowers are among the simplest subjects for photograms. Their colors can be reproduced realistically or not, depending on the filtration you use during exposure.

Large flowers may need some "surgery" so they transmit enough light. For example, flowers with lots of petals will not show their true colors unless many of the petals are removed. Roses fall into this category. You may have to remove most of the inner petals, leaving just the outer ones to give the flower its distinctive shape.

Some foods, sliced into thin sections, make suitable subjects for photograms. Look for bold colors. Oranges, bell peppers and tomatoes are ideal.

▲▶ You can make beautiful photograms by placing colorful flowers on color reversal paper. Thick flowers must be thinned out to make them translucent. For these Cibachrome prints, exposure was 30 seconds at ƒ-8, using 30M (magenta) filtration.

▼ For moist objects like this section of pepper, protect the printing paper with a plastic print envelope. Place the object on the plastic. Left: Made on color negative paper using 110Y + 70M filtration, plus an unexposed but processed color negative. Center: Ektachrome color reversal paper was exposed with 30M + 10C filtration. Right: Ektachrome paper was exposed for less time, with 30M + 30C filtration.

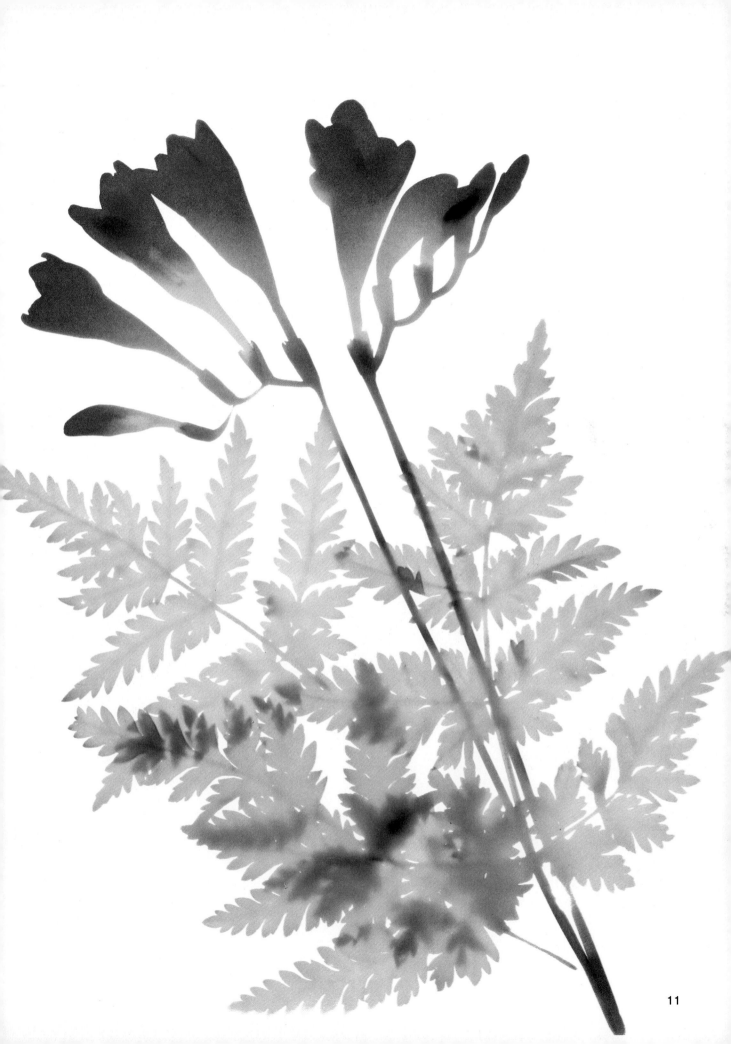

MAKING A COLOR PHOTOGRAM ON COLOR NEGATIVE PAPER

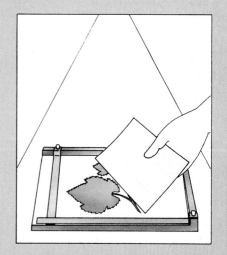

1) PREPARE THE ENLARGER
Set up your enlarger as if you were going to make normal color prints. Put a piece of unexposed but processed color negative film into the carrier instead of a negative. This provides the usual orange mask, and lets you use your standard filtration.

2) ENLARGEMENT AND FILTRATION
Adjust the height of the enlarger head so it evenly illuminates an area slightly larger than an 8x10 sheet of paper. Set the lens to f-8 and use your standard filtration plus the orange mask of the color negative in the enlarger. Turn off the room light and, if required, turn on a safelight with the appropriate filter. Place a sheet of color negative paper in the printing easel.

3) MAKE A TEST STRIP
Place a simple colored object, such as a leaf, on the paper. Use a piece of cardboard to make a test strip with exposures of 5, 10, 20 and 40 seconds.

▼ Green leaves were exposed on color negative paper with 110Y + 80M filtration for 18 seconds.

4) PROCESS THE PAPER
Process the paper and determine which exposure time gave the best density. Use your knowledge of color negative printing to modify the color reproduction. With color negative paper, you subtract a filter color from the filter pack to strengthen that color in the print. Color photograms usually require bigger filtration changes than normal color prints do.

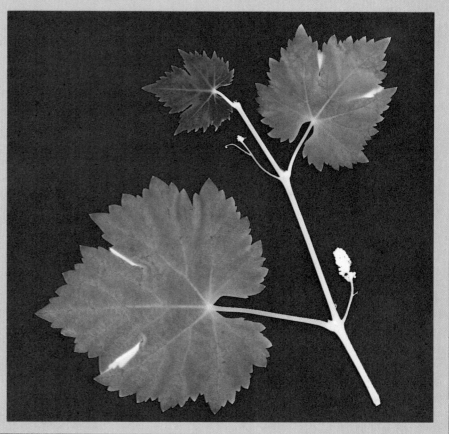

CREATED SCENES AND ABSTRACT PATTERNS

These categories challenge the imagination. By using tri-color filters and shaped cardboard masks, you can create colorful and realistic images on reversal paper. With a blue tricolor filter and a few twigs you can simulate moonlight over a rural landscape or a dark, haunted forest. Just remember to keep your compositions simple.

You can produce fascinating abstract patterns with cut glass or prisms. Use a small penlight covered with a piece of filter. Experiment by shining the light on the prism or cut glass at different angles. Then turn out the room light, position your glass object on the photographic paper, and repeat your experiments.

Two or three different exposures, made with a variety of color filters and penlight angles, will produce incredible colors and shapes. Exposure times will probably be about one or two seconds, depending on the power of your penlight.

The accompanying table shows the

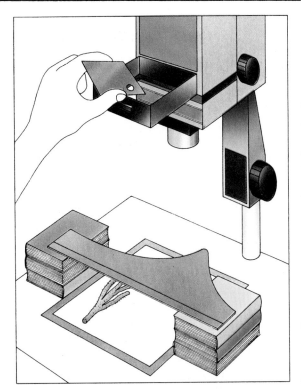

◄▼ To create a sunset scene on color reversal paper, David Nicholson used several items. To make the orange background, he used a piece of orange gel filter. To represent the sun, he punched a hole in the filter. The filter was placed in the negative carrier. The dark foreground line was a piece of cardboard supported by books a few inches above the paper. The mountain shape, cut from cardboard, was placed on top of the foreground cardboard, and a piece of cactus with a suitable outline was laid on the paper. Overall exposure was 20 seconds at ƒ-8 with 30M + 30C filtration. The mountain cutout was removed after 15 seconds, so that part of the print reproduced dark red.

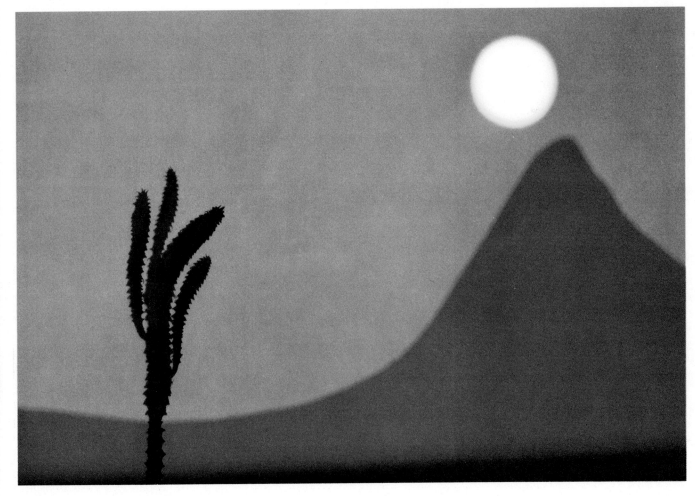

colors you can get with different filters and paper types. When planning scenes, consider the following color associations—red for sunsets and fires; green for landscapes; pale blue for snow; dark blue for moonlight; and cyan for the ocean.

EXPOSURE AND FILTRATION

With color negative papers, areas of the paper that receive the most exposure will be darkest in the photogram—as with b&w photograms. As shown in the table indicates, colored filters or objects will produce colors complementary to their own. This results in an abstract and often dramatic effect.

You may prefer the more realistic colors you'll get with color reversal papers. The resultant white background is usually appealing too. These papers will produce colors close to those of the objects, if you set exposure and color filtration correctly. To do this, set up the enlarger as you would for color slide printing. Give the same range of test exposures as suggested for color negative papers in the step-by-step illustrations on page 12. However, you should use a different starting filtration. Use the filtration you need for accurate color reproduction of a color slide. Examine density and color balance of the photogram print and make the necessary exposure and filter corrections, as you would if printing a color slide.

WORKING IN THE DARK

Working in the dark or under the appropriate dim safelight for color printing doesn't have to be difficult. A little preparation and practice can help things go smoothly.

With flat subjects, simply arrange your design on a sheet of glass with the lights on. Then turn off the light. In the dark, place a sheet of printing paper—emulsion side down—over the objects and cover the paper with another sheet of glass. Turn this sandwich over, place it under the enlarger, and make the exposure.

With large or bulky objects, you'll have to use the appropriate safelight for your color paper. Safelights for color materials are very dim and cannot be used for long, but you can minimize these problems in a couple ways. First, decide what your composition is going to be and practice positioning the objects until you can do it quickly. Second, before you remove the printing paper from its packet, allow your eyes 5 to 10 minutes to become accustomed to the dim light.

▼ For this striking abstract design made on color reversal paper, a penlight covered with a color filter was used to expose a prism set on the paper. Several one-second exposures were made. The filter color and the position of the penlight were changed for each exposure.

USING FILTERS FOR DIFFERENT EFFECTS

FILTER COLOR	PRINT COLOR	
	Negative Paper	Reversal Paper
red green blue	cyan magenta yellow	red green blue
cyan magenta yellow	red green blue	cyan magenta yellow

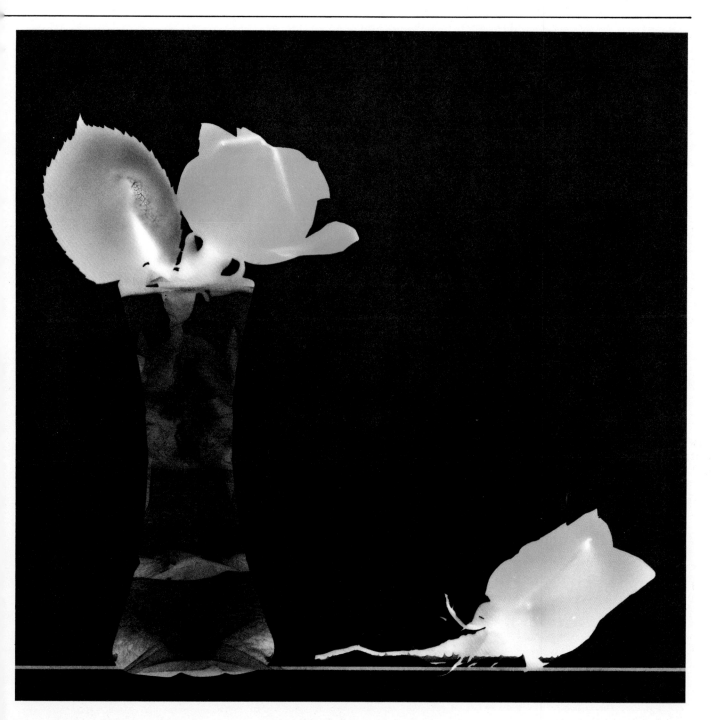

▲ To produce this unusual composition on color negative paper, David Nicholson cut roses in half and removed the center petals. The roses and glass vase were laid on the paper along a glass sheet for the "table". He used a 20-second exposure with 80Y + 50M filtration.

Adding Texture

Adding apparent texture to your prints is one of the simplest and most effective special effects you can produce in your darkroom. The possible effects are many—from simple lines to coarse patterns to dazzling moiré images. Generally, subtle effects enhance the image; bold textures draw attention to themselves.

Part of the fun of this technique is seeing how different texture patterns affect different images. At first, you'll find some effects that don't work and some that work well. As you gain experience, you'll develop a "feel" for what textures enhance various types of images. Some general guidelines are mentioned and illustrated here.

USING TEXTURE SCREENS

Texture screens can be used in two ways—by sandwiching a small screen with the negative in a glass negative carrier, or by sandwiching a large screen in contact with the printing paper. Commercially available texture screens are available, or you can make your own.

CHOOSING AN IMAGE

As with any graphic effect, the simpler the image the better. Texture screens are especially good for breaking up large areas of one tone. If you have an image that has texture of its own, such as an old stone building, a superimposed pattern can clash with the inherent texture. Likewise, a subject that has a lot of details, such as a landscape, may look too busy if texturized with a screen.

MAKING YOUR OWN SCREENS

When you shoot your next roll of b&w film, try setting aside perhaps six frames for recording different textures. Or, you might decide to use a whole roll for this purpose.

You want a thin negative, so it won't be an obtrusive screen. Therefore, when shooting a texture screen you should underexpose by at least two steps. Lighting on the subject should be uniform. Process the film normally. Some photographers prefer to overexpose the film and then underdevelop it to retain clear detail.

Finding Texture—You certainly won't have to search far. It's all around you—concrete, pavement, brick walls, sand, sandpaper, wallpapers, crazed ceramic surfaces, ceramic tiles, leather, textured glass and fur are just some potential texture subjects.

For large screens that go in contact with the printing paper, you'll need a variety of translucent materials, each large enough to cover the printing paper. Fine silk, chiffon, muslin, net curtain material and tissue paper are suitable.

SANDWICHING SCREENS

The most controllable way to put texture in a print is by sandwiching a small texture screen emulsion-to-emulsion with the negative in a glass negative carrier. Then make the print in the usual way. If you want a more diffuse effect, sandwich the screen and negative back to back.

Because the the screen has density, more exposure is necessary. It's a good idea to make test strips for exposure and, in color printing, color balance.

CONTACT-PRINTING SCREENS

When a large texture screen is used in contact with the printing paper, the screen and paper must be in firm contact. Use a clean sheet of heavy glass or an unmasked contact frame to assure firm contact. If the contact screen is used for the entire exposure time, its affect is often too coarse. You'll probably get best results by using it for only a portion of the time, about 50%.

▲ Matching the texture screen to the mood of the image is important. Here, a Paterson Rough Etch Screen emphasizes the historic setting.

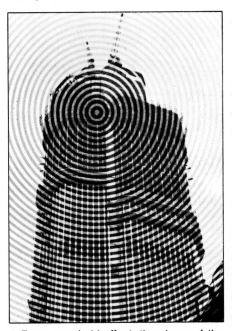

▲ For a very bold effect, the shape of the building was carefully matched to the geometric lines of a Paterson Centric Screen.

▶ Be sure your homemade texture screens are not too dense. For the screen used here, the film was briefly exposed in contact with a sheet of dry-mount tissue. Then it was deliberately underdeveloped to produce subtle texture.

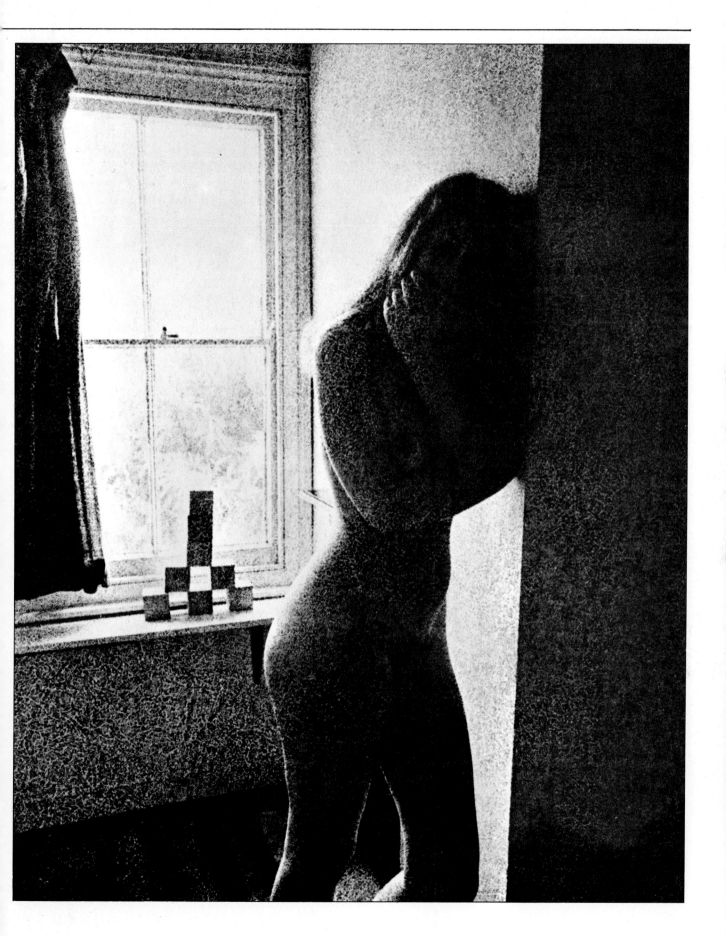

▲ The texture of white ceiling tile lit from the side was used with an overexposed portrait to produce a painterly effect.

▲ Right: Monochromatic color and simple shapes in the image work well with the Paterson Rough Linen Screen.

▶ The texture for this sunset image came from a screen made from a photo of a backlit piece of fabric.

SOME HOMEMADE TEXTURE SCREENS

GRAINED LEATHER

ENLARGED MAGAZINE ILLUSTRATION

WEATHERED PLYWOOD

CLOTH

ROUGH WOOD

BRICK

ROUGH WALL

PAPER

ENLARGED MAGAZINE ILLUSTRATION

WALLPAPER

UNDERSIDE OF LINOLEUM

SILK

Diffusion and Distortion

Sometimes, printing your negatives normally won't give the most pleasing print. When this happens, consider transforming the image during printing. Here are a couple easy ways to do it.

DIFFUSION

In normal printing you try to make sure the print image is as sharp as possible. But doing the opposite—diffusing part or even all of the image—may help. Diffusion causes less-important image details to merge, so that attention is concentrated on the details you want people to notice.

Soft and misty images tend to go with mellow thoughts and subjects—the sort of thing inspired by weddings, babies, beautiful flowers, and other pretty scenes.

Diffusing Materials—What you choose to hold under the enlarger lens to diffuse the image depends most on the effect you want. You can produce a very slight diffused effect by painting clear nail polish on a sheet of clear glass. Or you can crumple cellophane, then flatten it out again and attach it over a hole in a sheet of cardboard. Black nylon stocking can be stretched over a sewing hoop. If you want to diffuse only part of a print, you can smear petroleum jelly lightly over the appropriate areas of a sheet of glass positioned over the printing paper.

Whatever material you choose, remember that the image must pass through the diffusing material. If the scrambling effect is too strong, the result could be a mess instead of an improvement. Another point to keep in mind is that diffusion tends to reduce contrast, so you may want to work with a more contrasty grade of paper than usual when making diffused b&w prints.

Making The Print—Make a test-strip print in the usual manner to determine best exposure, paper contrast grade in b&w, and color filtration in color. Be sure to have the diffusing material in position under the lens when you do this, because the material can affect exposure, contrast and color balance.

The height of the material above the printing paper affects the degree of diffusion—the nearer it is to the enlarger lens, the greater the effect. If you want to simplify things, use one diffusing material and vary exposure time with it and its distance from the print.

It's a good idea to move the diffusing material continuously during all or part of the exposure, especially if it is near the print surface. This keeps marks or patterns in the material from appearing as obvious blemishes in the print.

▶ A motorcycle is an unlikely subject for diffusion, but the blurring shown here suggests motion. Photo by Ralph Court.

▼ Get a variety of diffusing materials and experiment with them by varying the distance between the diffusers and the lens. You can lessen the effect by using the diffuser during part of the exposure.

▲ Darkroom diffusion requires an image with strong contrasting areas, preferably close to one another. When working from negatives, remember that you'll be spreading the shadows into the highlight areas.

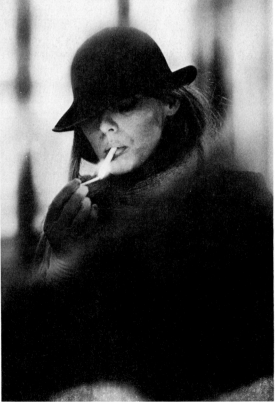

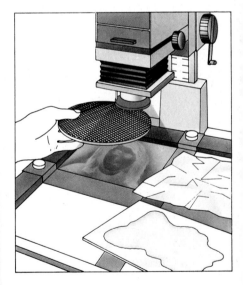

◀ To produce this diffused effect, the photographer held a sheet of glass smeared with some **petroleum jelly** over the paper during the print **exposure**.

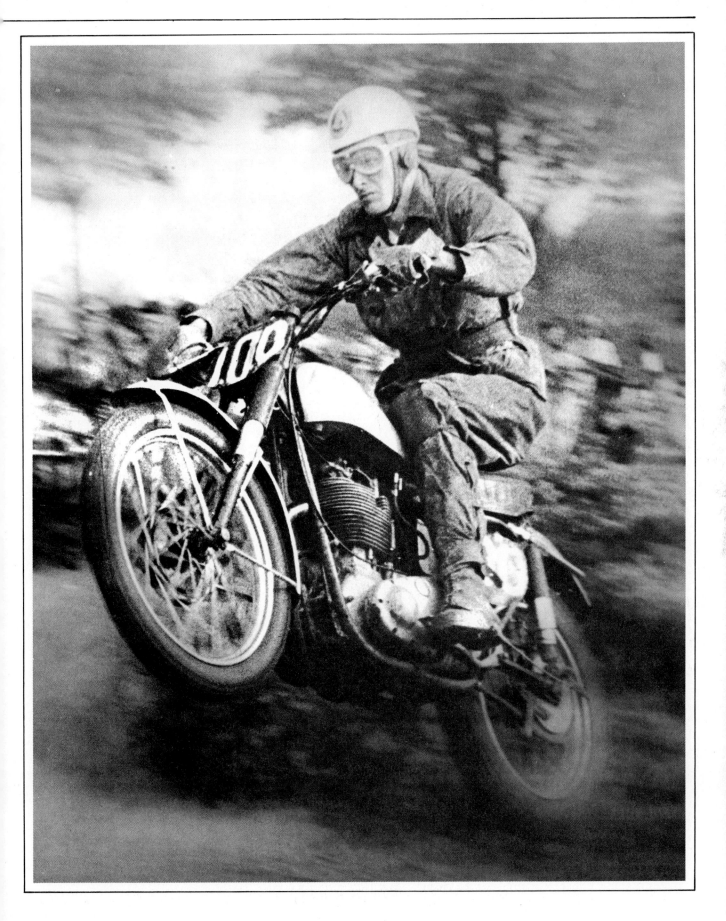

Working In Color—When you print color negatives with diffusion, you get the same effect you get when printing and diffusing b&w negatives—shadow areas spread into the highlight areas of the image in the print. This is a somewhat unnatural effect, and tends to result in prints that look darker than undiffused prints, but it can be pleasant nonetheless.

When you print color transparencies on color reversal paper and diffuse them, light from the highlights spreads into the shadow areas of the image. It's a natural effect similar to what you get when you use a diffusion accessory over a camera lens.

DISTORTION

You can distort the image by bending or kinking the printing paper so that it is not flat while it is being exposed under the enlarger. As you'd expect, distortion produces some weird effects suitable for some images and not suitable for others.

Selecting The Image—Images with definite, easily identified shapes work best with distortion. A negative of tree branches is not a good choice, because the distortion effect will be lost. Who's to say that the tree doesn't have distorted branches?

Familiar subjects, such as statues and buildings, have simple, clear shapes well suited to distortion. The human face and figure also work well. Gestures can be exaggerated or created by distorting the paper, and facial features can be enlarged

all out of proportion like the effect of a funhouse mirror.

It's best if you use a simple, plain background that won't show the distortion as clearly as the main subject does. This way, the distorted effect on the subject will be isolated and even more striking. Bright, white, clear areas of sky make an ideal background for distortion subjects, as do blurred backgrounds.

Making The Print—Before you begin, gather up a few small boxes of different sizes to act as supports for your distorted printing paper, along with some masking tape to hold the paper in position.

When you've done that, rotate the enlarger's red safety filter into position under the lens, or tape a deep red filter under the lens if the enlarger doesn't have such a filter. This allows you to project an image on the paper without exposing it. You can then see the distortion effect as you bend the paper.

Position a sheet of printing paper under the enlarger. Gently flex the paper until you see an effect you like. Then use your small boxes and masking tape to support the paper in that position. Use small pieces of tape because you'll have to trim the marks they leave from the finished print. Use strong tape because modern resincoated (RC) paper is very springy.

When the paper is in position, switch off the enlarger and remove the red filter from the light path. You are now ready to expose the paper. Determine your basic exposure time from a test strip.

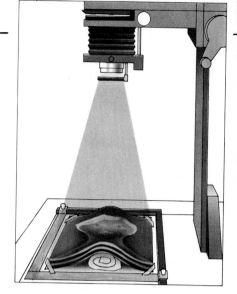

▲ Firmly fix the paper in position before you make a print with distortion. If the paper moves during exposure, you'll have to start again.

However, this time applies only to those sections of paper lying on baseboard. The raised areas of the paper are closer to the lens, and so receive more exposure. Therefore, you'll have to dodge them for part of the exposure time to compensate. You'll have to do some testing to determine the amount of dodging needed. After exposing the paper, process it in the usual manner, and enjoy your creation.

▲ Consider using a portrait with a plain background when making a distorted image.

▲ With the paper curved and bent, you'll have to stop the lens down to a small aperture to keep the print sharp overall.

▲ If you create extreme distortions, take care when bending the paper so light does not reflect from one part of the paper surface to another.

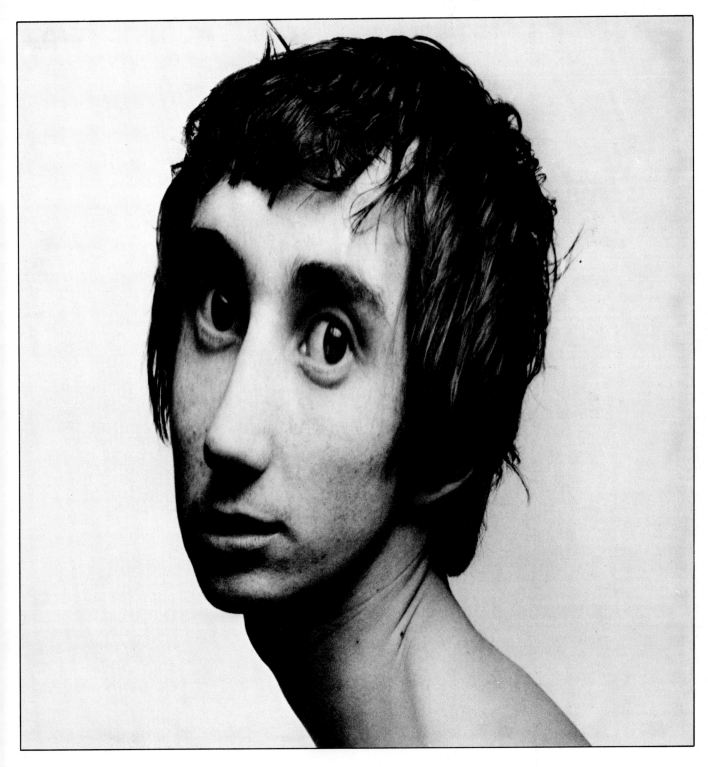

Combination Printing

Combining different negatives to produce unusual images is not a new technique, but it's very useful. A popular trick among early photographers was to use a separate negative of clouds to add visual interest to a scene with a blank, dull sky. You can do this too. You can also create some very beautiful and unusual effects by imaginatively combining widely different subjects in one print.

Several methods are available. One way is to carefully double-expose the film in the camera. In the darkroom, the basic methods are successive printing and sandwiching.

EQUIPMENT

Along with your usual darkroom equipment, you'll need a wide selection of negatives. If you have a negative file and proof sheets, sort through them to decide which images might work well together. Simple images have greater visual impact than complex ones and make it easier to merge images. If you don't find any suitable negatives in your files, you can go out and shoot some with combinations in mind.

Aside from these things, you'll need a sharp-pointed pair of scissors, some thin cardboard, a pencil, and a set of dodging tools.

SUCCESSIVE PRINTING

This technique allows more creative freedom than sandwiching does. With this method, you print two or more negatives in succession on the same sheet of printing paper. The basic procedure is shown in the step-by-step illustrations.

Don't feel disappointed if your first attempts aren't exactly what you had in mind. Mastering combination printing requires practice and patience. Complex combinations requiring custom-cut dodging tools take a lot of effort. But if you keep at it, you'll succeed.

If your first combination print is not satisfactory, keep it anyway for reference. Practice by adding clouds to another photograph to make it more interesting, as early photographers did. When adding

▶ Keep your first attempts at successive printing simple. Here, the cat negative was printed first while the other part of the paper was dodged. Then the negative of the people was printed while the already exposed area was dodged.

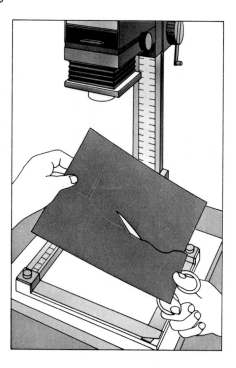

▲ The second image contains clouds that can enhance the main image.

▼ The main image has an overexposed, washed-out sky.

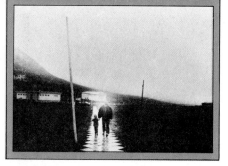

1) CREATING THE PICTURE
Select a negative with a light, featureless areas, such as the sky. Place it in the enlarger and compose and focus its image on a sheet of plain paper. Trace the main outlines on the paper. Remove the first negative and insert the second, which will provide the missing detail. Arrange its image as you want it to fit with the first. Draw the main lines on the same sheet of paper.

2) MAKING THE MASK
When you're satisfied with your layout, remove the paper and substitute a sheet of thin cardboard the same size. Using the main negative's projected image, outline the boundary between the two images. Cut along this line carefully, and you'll have two *dodging masks*. Now make test strips of each negative to check exposure.

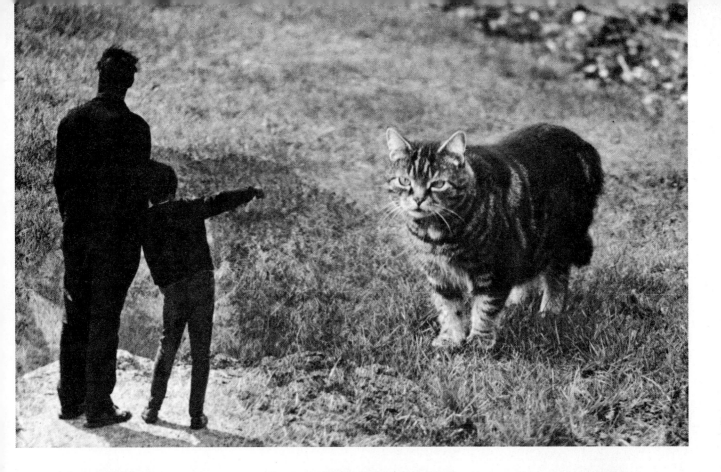

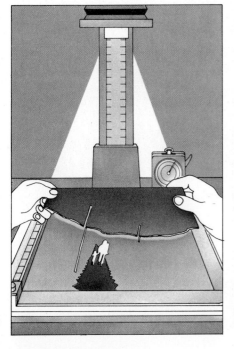

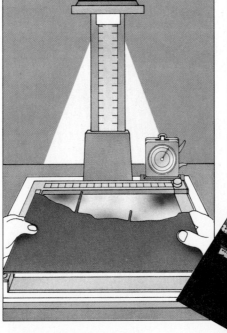

3) THE FIRST EXPOSURE

Place a sheet of printing paper in the easel, making sure it rests firmly against the stops. Expose the first negative, covering the area of the second negative's image with the cardboard mask. Keep the mask moving slightly to avoid a sharp line of demarcation on the print. Remove the paper and make a dot in the top right corner of the border area with an indelible marker that you can see under safelight. Place the paper in a light-tight container.

4) THE SECOND EXPOSURE

Put the second negative in the carrier, place the paper layout in the easel, then align and focus the second image. Turn off the enlarger, remove the layout paper and replace the exposed printing paper. Make sure the dot is at the top right. Make the second exposure, with the second mask covering the area previously exposed. Again, keep the mask moving. Process the print as usual.

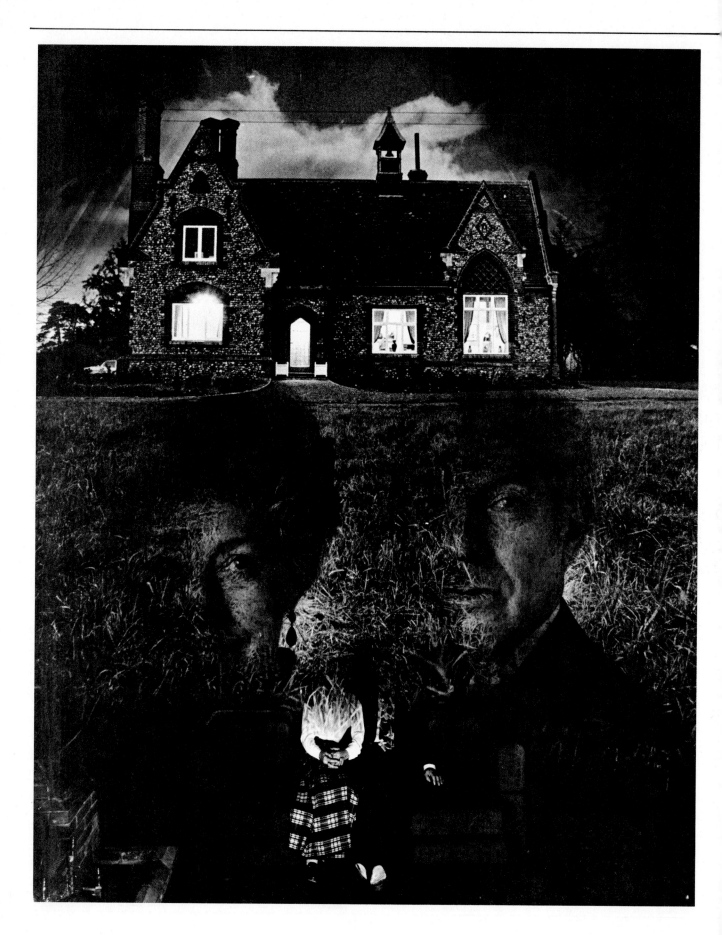

cloud background or leaf-and-branch foregrounds, you'll find it easiest to print the main image first and the clouds or branches second.

If a thin line shows around a combined image, it could be caused by several things—you may not have cut the mask accurately enough; the mask may not have been positioned properly; or the mask may have been poorly manipulated during printing.

You'll find it easiest to work with negatives made with a specific combination image in mind. For example, to put an object into a bottle, photograph an empty bottle against a white background. Light the scene to avoid highlights on the glass. Then photograph the object against a light background. Print the resulting negatives in succession on a single sheet of printing paper to produce the desired result. The dense background areas of the negatives act like masks.

GHOST IMAGES

The easiest way to produce ghost images is by making a double exposure in the camera, but you can also do it by successive printing. For example, take a negative of a landscape or an interior, and another of a figure against a white background such as a wall.

Then expose the negatives in turn onto one sheet of printing paper, using the combination printing technique. The ghostly figure will appear superimposed over the background.

Try using color transparencies. When printed on b&w paper, they become negative images. For example, a positive transparency of a white cat with light eyes will produce a black cat with black eyes in a b&w print. With a bit of thought, you'll be able to come up with many uses for these negative images in your combinations.

NEGATIVES AND PHOTOGRAMS

For a more graphic look, combine a negative with a photogram. For this technique, you'll need a sheet of glass large enough to cover your printing paper.

Place the negative in the carrier and focus the lens sharply. Then place your

◀ After a lot of practice, you'll be able to make multiple-image prints this complex. The photographer used *five* negatives—the house and grass, two separate portraits, the interior with the sofa, and the sky. Prints this complicated are easier to do if you print successive negatives in more than one enlarger. This way you set each enlarger once.

photogram objects—broken glass, leaves, torn paper, netting, seeds, beads or anything that will make a good picture—on the sheet of glass. Carefully position the glass over the paper. Expose the negative onto the paper through the objects on the glass sheet, and you've made a combination photogram.

OTHER COMBINATIONS

You can print one negative repeatedly on one sheet of paper to form a pattern or an interesting effect. For example, a photograph of seagulls, taken against a clear sky, can be printed several times to give the effect of a sky full of seagulls. Each time the paper is re-exposed, the print will become darker, so you must allow for this when you plan your image.

Multiple-printing techniques will be discussed in another section, pages 32 to 35.

RETOUCHING

Sometimes, you'll have to do a little retouching on the final print to blend tones of adjacent areas. Typically, these are edges between images from different negatives. Retouch with standard print-spotting dyes applied with a fine sable brush.

▼ Simple changes of scale produce strange effects. The main image is a man standing on a stone dam with the shore around him. It was combined with a negative of clouds appearing much closer than normal, giving an intriguing finished picture.

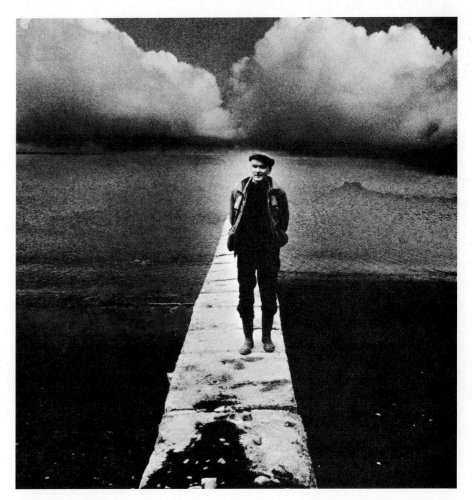

Negative Sandwiching

This technique is an easy way to do combination printing. You take separate negatives—usually two—and place one on top of the other, then place this sandwich in the negative carrier and project it onto a sheet of printing paper. The result is a photo with details from two negatives.

SELECTING THE NEGATIVES

For b&w sandwiching, select negatives that have some clear areas. This way, dark parts of one negative can print through clear areas of the other. By sandwiching, you can get detail and texture in areas that would normally print black. The photos of this section illustrate this point well.

To find good negatives for sandwiching, hold different combinations in front of a light source. Move the negatives around relative to one another. If you're using 35mm or smaller negatives, you may find it easier to project the various negative combinations with your enlarger and examine the enlarged image on your printing easel.

Often, the ideal composition with sandwiched negatives occurs with the negatives off center. When this happens, the sandwich may not fit into your negative carrier. Solve this problem by placing the sandwich in a carrier made for larger negatives. Mask the open areas with black tape.

EXPOSURE

Because you're exposing through two or more negatives, there's a build-up of negative density where images overlap. Therefore, exposure times will be longer than if you were printing only one negative. In addition, some combinations require a lot of burning-in to bring out details. With test exposures and experience, you'll learn what works.

For example, you'll quickly find that opening the enlarger lens won't necessarily solve the problem of long exposures because one negative will print through sharper than the other. This happens because the two images are separated by one thickness of film base, putting them at slightly different distances from the lens. You should focus between the two images, and close the lens down to a small aperture, such as f-11. If the combination image works with the negatives sandwiched emulsion to emulsion, you won't have this problem.

Increase the interval of your test strips from the usual five seconds to 10 seconds for sandwiches. With very dense combinations, you may have to use 20-second intervals. You can try opening the

lens one step for burning-in, but do this on a test print before trying it on the final print.

MAKING BLACK BACKGROUNDS

When you're purposely shooting subjects with sandwiching in mind, you'll find it useful to take along a piece of black velvet or other cloth as a portable background. Light just the subject in front of the background. The resulting negative then reproduces the background essentially clear, with detail in the main subject only.

Sandwich a clear-background negative with almost any other negative to add the background of your choice to the image of your main subject. For example, if you sandwich a close-up negative of leaves or other shapes and patterns with the black-background negative of your subject, the resulting print shows foliage or the patterns around your subject. The new background prints faintly through the subject, too, because the subject's image on the negative isn't totally opaque.

You can sandwich a texture screen emulsion to emulsion with your subject

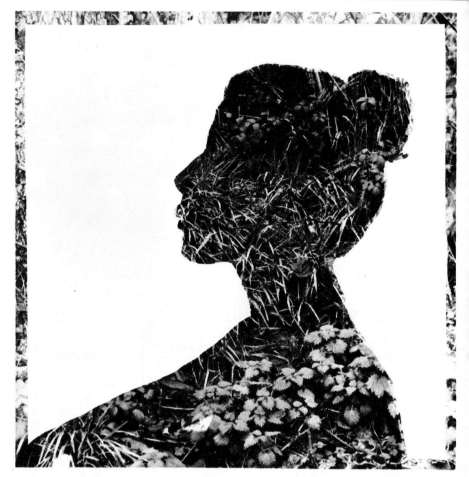

▲ Make a picture like this by photographing your unlit subject against a white background. Then sandwich the negative with a negative of foliage. You'll get a print with foliage in the shape of the silhouette.

SELECTING NEGATIVES FOR SANDWICHING

Selecting the right negatives to sandwich is very important. One of them should have a large clear area through which the details of the second negative will print. Here, a landscape with dark rocks that appear almost clear on the negative was chosen as a background for the portrait. The printing-through of rock textures in the skin areas adds interest. Photos by Ian Hargreaves.

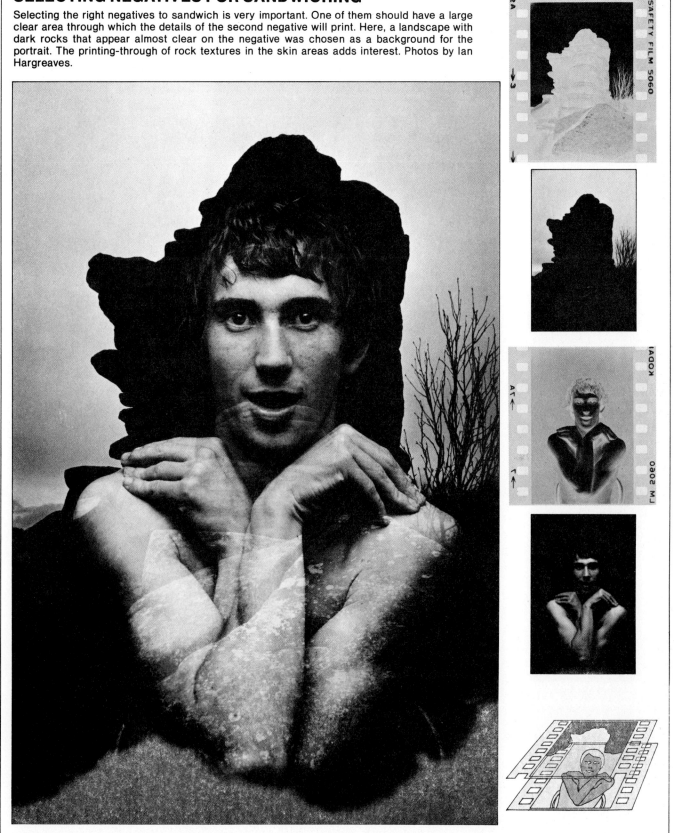

negative to produce a print with an overall speckled, etched, canvas or crazed appearance. Texture screens are available from your photo dealer, or you can make your own as described on pages 16 to 19.

SILHOUETTES

Produce striking prints by sandwiching a negative or texture screen with a silhouette negative. Make one by placing your subject in front of a *white* background. Light just the background, meter it only and set exposure settings as indicated. The resulting negative contains a clear image of the subject and a dense background. Outdoors, you can produce a silhouette by photographing your subject against a bright sky. Base exposure on the sky.

When you sandwich the silhouette negative with another negative, the silhouette's background will print white because it is so dense. The details of the other negative print through the clear areas of the silhouette negative, giving a silhouette full of details.

SANDWICHING COLOR IMAGES

Because of a built-in orange mask, you can't sandwich color negatives very successfully. But you can combine a color negative with a color transparency, or sandwich two color transparencies. If you don't make color prints yourself, you can take your sandwiches to a custom printing lab for printing.

As with b&w sandwiches, select images with pale or colorless areas. Such images combine well artistically and are easy to print. You'll probably have greatest success using images you photograph specifically for sandwiching. Don't discard your washed-out, overexposed slides that look disappointing when projected. Save them because they're useful for slide sandwiches. It's a lot of fun creating unusual effects or simply adding more interest to an otherwise dull image.

When you assemble a sandwich, make sure that each color image is clean and dust-free. Then bind the images together at the edges in the desired relationship with transparent tape.

▼ Precise alignment between two images is particularly effective here. The radiating lines of the dandelion emphasize the spreading beams of the sun, while contrasting with the solid line of the hills.

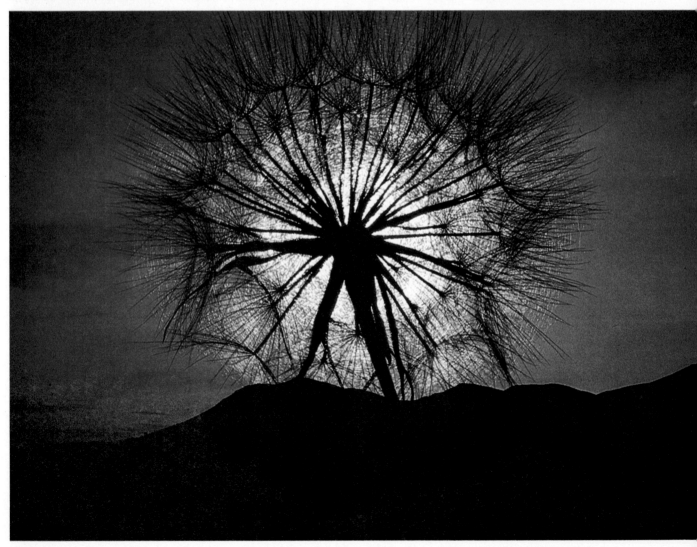

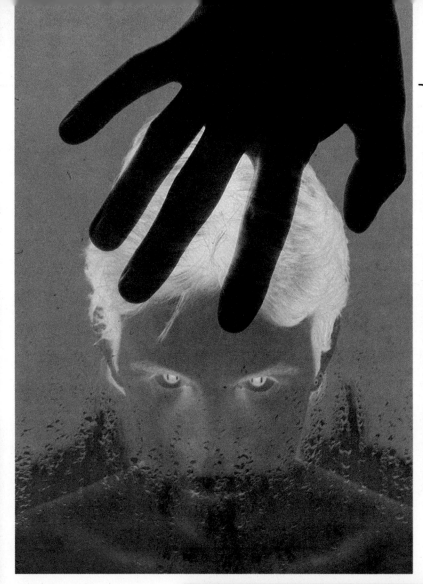

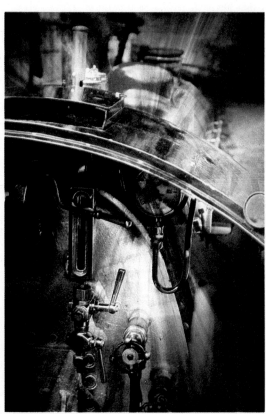

▲ Photos used here were a slide of train controls and an overexposed zooming picture. The spreading blue rays give a futuristic effect.

▲ Here's a good example of the effect you can get by combining a color negative and a color slide. The portrait negative was sandwiched with the slide of a hand spread over a pane of glass containing water droplets.

▶ One of the easiest ways to make a sandwich is to combine two slides. You don't even have to make a print—you can put them together in one mount and project them just as you do your other slides.

Multiple Printing and Movement

Normally, you keep the printing paper in one place when enlarging. But moving it during exposure can produce a variety of effective photos. Some are repetitive images, a single image with streaks of apparent motion, and a print with ghostly afterimages.

CHOOSING THE NEGATIVE

When you're selecting a negative for multiple printing, first make sure that it's simple. Complicated images lessen the impact of repeated imagery.

Second, the negative's background must be dense black. This way it blocks exposure to the paper, acting as a mask and allowing you to print the main image again in a previously unexposed area. If you work with a large-format copy negative, such as on 4x5 film, you can mask the area around the subject by painting opaque retouching fluid on the film base.

Subjects whose action has been "frozen" on film are ideal for multiple effects—for example, a sprinter dashing for the finish line, a tennis player serving or a dancer leaping. You can also use less obvious action, such as a close-up of hands playing the piano.

You may prefer to choose an inanimate object that is simple and symmetrical. Spend some time thinking through a certain idea. Plan your steps before trying to make a multiple-image print. Sometimes, it helps to make repeated tracings of your enlarged image to get an idea of how the finished result might look.

MAKING MULTIPLE IMAGES

Basically, you expose the image several times in different parts of the printing paper. You move the paper between each exposure. This gives a series of images on the print. They can be distinctly separated, or you can make them overlap slightly.

They can be of equal density, or you can make them progressively fainter by reducing the exposure as you print each successive image. With all of these possibilities—and more—you can see why it's a good idea to think about your composition before you start to print it.

Making a Tracing—This is the first step in creating a multiple-image print. Place the negative in the carrier and project and focus the image on the back of an old print in the easel. Trace in the first image. Move the paper until you think that the spacing looks right, then trace the second image. Continue until you have traced at least five or six images. You'll use this paper to work out the appropriate spacing of the images for your multiple-image print.

The Test Series—Now make a test strip to find corect exposure settings. Having found them, take a half sheet of printing paper and make a test series to help you work out final adjustments in the spacing

of the images, and to make sure that you aren't getting a density build-up in the white background area.

There will be an unavoidable density increase where images overlap, but if density appears in the white background area, try using a more contrasty paper—for example grade 3 or 4.

With your tracing, you know how much to move the paper each time to produce the desired image spacing. Now you need a way to move the paper by this amount after each exposure. You can "eyeball" it, or mark the easel positions on the enlarger baseboard with masking tape or erasable marking pen.

REVERSE IMAGES

To reverse images laterally on each side of a central point, mark the end of the image just exposed with a wax-pencil dot. Put the paper into a light-tight box. Flip the negative over in the carrier and refocus, then position the enlarger's red safety filter under the lens. Reposition the printing paper, using the dot as a reference. When you've got the image where you want it, turn off the enlarger and remove the safety filter from the light path. Replace the printing paper in the easel and make your exposure.

CIRCULAR PATTERNS

Printing images in a circular pattern is slightly more complicated, but esthetically well worth the effort with suitable subject matter. To do it, you must rotate the printing paper around a central point. You can do this by securing the paper to the enlarger baseboard with a pin through the paper's carefully measured center. This puts a small hole in the print, but enables you to turn the paper freely and accurately. If the idea of a hole in the print bothers you, stick a thumbtack into the

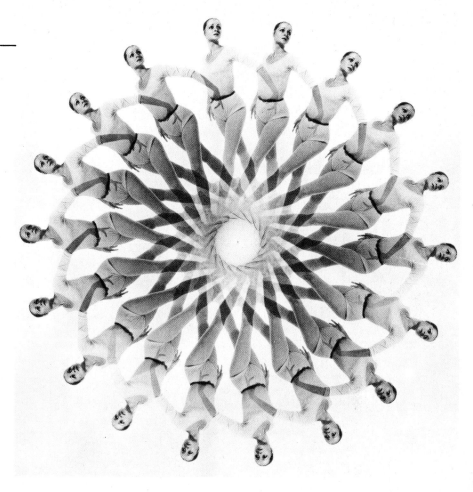

center of a sheet of corrugated cardboard and turn it over. This gives an improvised turntable on which you can tape the printing paper.

To get some idea of the final effect, you need to make a tracing. Take a sheet of plain paper the same size as your final print and thumbtack it through the center to the baseboard. Project the negative and trace the first image, then rotate the paper until you are satisfied with the spacing. Trace the second image. Measure the distance between identical points on each image, then turn the paper until this dis-

▲ Create a geometric pattern by pinning the paper to the baseboard and turning it a measured amount between exposures.

tance exists between those points on the second and third images. Trace the third image.

Continue in this way until the circular pattern is completed. Make any necessary spacing adjustments with the tracing, then use the tracing as a guide to make your print.

Making The Print—Make a test strip to determine correct exposure. Make the

◄ A white background is essential for making multiple-image prints from one negative. A simple, elegant image is useful, too. You can create a chorus line from a negative of one dancer by moving the paper a measured distance between exposures. Photo by Amanda Currey.

▶ If you don't already have a negative of a suitable subject against a white background, make one! Here, a negative of a glass decanter shot from above was used. The negative was flopped for the second exposure.

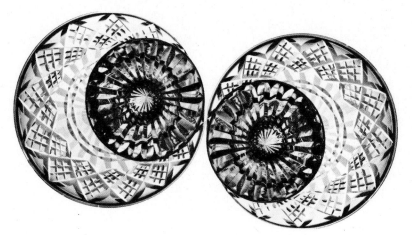

first exposure, then swing the red safety filter under the lens and make a tiny cross just above the position of the first image, using a black wax marker. Use this mark as a starting point to measure the correct distance between images, and rotate the paper the desired amount. Remove the red filter and make the second exposure. Continue in this way until the circle of images is complete. The marker will wash off in the developer.

MAKING STREAKS

You can produce steaks that will give your image a feeling of rapid motion by moving the paper during exposure. Expose the paper normally for three-quarters of the exposure time, then move it slowly and smoothly in one direction during the rest of the exposure. If you'd like the streaks to taper off, increase the speed as you pull the paper across the baseboard. The print will show a sharp image with streaks flowing from it. To make sure the streaks are straight, tape a ruler to the baseboard and slide the easel containing the paper along the straight edge.

Ghost Images—To produce ghost images instead of streaks, allow the paper to remain stationary for a few seconds between movements.

MOVING THE ENLARGER HEAD

Instead of moving the paper during printing, you can move the enlarger head

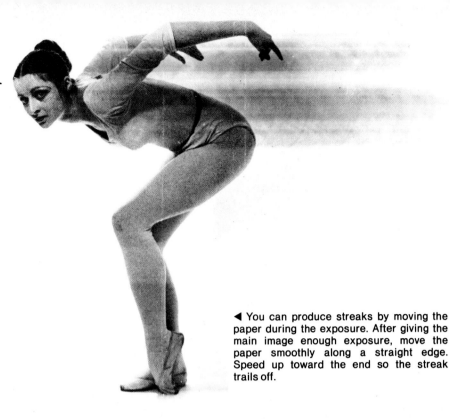

◀ You can produce streaks by moving the paper during the exposure. After giving the main image enough exposure, move the paper smoothly along a straight edge. Speed up toward the end so the streak trails off.

to create multiple or blurred images. You'll need to choose a simple image, such as a face or a flower against a white or pale background.

For a blurred effect, focus the negative with the enlarger head low on its support column, and stop the lens down to its minimum aperture to increase overall sharpness when you make the print. Make a test strip to determine the correct exposure. When you make the print, expose the paper normally for half of the exposure time, then crank the enlarger

head up to the top of the column during the second half of the exposure. This will produce a slightly blurred three-dimensional effect.

For a less-continuous effect, expose the paper normally for three-quarters of the time, then move the head up the column in four separate increments, giving the paper a quarter of the remaining exposure time at each stage. Swing the red safety filter under the lens or switch the enlarger off while you move the head.

▶ To create ghost images, make an initial near-normal exposure, then move the paper along a ruler for a set distance between exposures. Progressively shorten exposures so that the resulting images become fainter. Photo by Amanda Currey.

▶ If you want to make a multiple print from a transparency, choose a simple image with a dark background.

▼ Working in color is more difficult than in b&w because you have to do it in complete or near-darkness. Instead of making marks on the print surface, tape a series of cardboard pieces to the easel or baseboard so you can feel them in the dark. For this example, a circular pattern of cardboard stops was made. The transparency was then enlarged onto an intermediate negative, with the floor masked out. This negative was then enlarged on color negative paper normally. Photo by Amanda Currey.

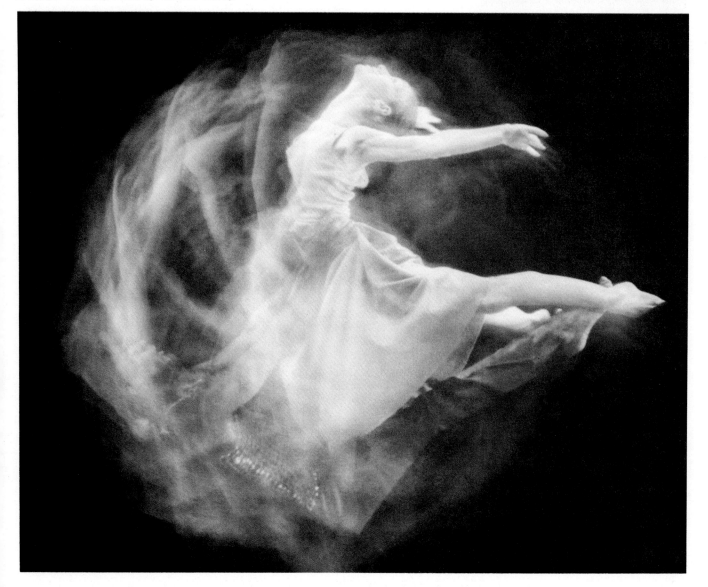

Push-Processing

The prospect of taking pictures in dim light makes many photographers reach for their flash units. But there's another way to handle shooting in dim light. You expose the film as if it had a higher speed than the manufacturer says, then change the development to compensate for underexposure. This is called *push-processing.*

It's useful when you want to preserve the natural effect of the existing light, when auxiliary light sources are either not available or not permitted, and when the use of both a short exposure time and a small lens aperture is desired, as when photographing a fast-moving subject with a telephoto lens. It is also handy when the light is dim and you don't have a tripod or other camera support.

Push-processed film shows more graininess, more contrast, less shadow detail and less sharpness than film exposed and developed normally. And, push-processed color films generally show an adverse color shift. Even so, push-processing can make it possible for you to shoot in lighting conditions that would not permit it otherwise. In addition, the push-processed "look" can give extra impact to some pictures.

HOW FAR CAN YOU GO?

From a technical standpoint, film speed can't be increased more than about one exposure step if you use readily available techniques. But from a practical standpoint, you can push the effective speed of b&w film up to three steps for most pictorial purposes. You can push color slide film one step with good results, and up to three steps with acceptable results. Color negative film can be pushed one step with acceptable results, and up to three steps for special effects.

How far you can push film speed depends in part on the method you use, and in great part on what you are willing to accept in terms of image quality—or lack of it. The more you push film speed, the worse image quality becomes. So push only when you have to, and then only as far as necessary.

Because push-processing tends to increase image contrast, you can push film speed farther when photographing low-contrast scenes than when shooting scene of normal or high contrast.

A point of interest: A film's ISO (ASA/DIN) speed is the speed at which the manufacturer rates it. Any other speed at which you rate it is called an exposure index (EI). Both ratings are used the same way—set your light meter's or camera's film-speed dial to the desired speed, and expose accordingly.

PUSHING B&W

Although you can use ordinary developers for push-processing by extending development time, it's better to use a specially formulated "speed-increasing" developer such as Perfection XR-1, Edwal FG7 or Acufine. With these, you'll get best results—more film speed with less loss of image quality. Be sure to follow the manufacturer's instructions carefully when using one of these products.

If you choose to use extended development in a normal developer, increase development time 50% for a one-step speed increase, and 100% for a two-step increase. To push film speed more than two steps, use a speed-increasing developer. Don't try extended development with a fine-grain developer, because fine-grain developers produce less film speed in the first place. Extending development only negates their fine-grain properties.

You'll get the best tonal range in your photos if you use fast film to start with. For example, it's better to use Kodak Tri-X or Ilford HP5 exposed at their normal speed rating (ISO 400/27°) and developed normally than to use a slower film pushed to EI 400.

PUSHING COLOR SLIDES

Consider pushing color slide films that use E-6 processing, which is available in kit form from your photo dealer. What you do is increase the first development time 50% for a one-step increase. Increasing first-development time by 80% gives a two-step increase, and a 125% time increase pushes speed by three steps. Use recommended processing times for other chemical steps.

Kodak offers a special ESP-1 processing mailer for a one-step Kodak push-processing of Ektachrome films. Many independent labs will also push color slide films for an extra charge. Very few labs will push Kodachrome films, due to the

▶ ISO 400/27° color slide film pushed two steps to EI 1600 will produce more grain and less sharpness than normal, but the effect can be used successfully. A subject like this is well-suited to the effects of push-processing. Photo by Michael Boys.

◀ Color negative films can be pushed successfully if accurate color reproduction and fine grain aren't important. This picture is a print from a small section of a 35mm Fujicolor 400 negative exposed at EI 3200. The dancer was lit by colored lights, so accurate color reproduction wasn't critical.

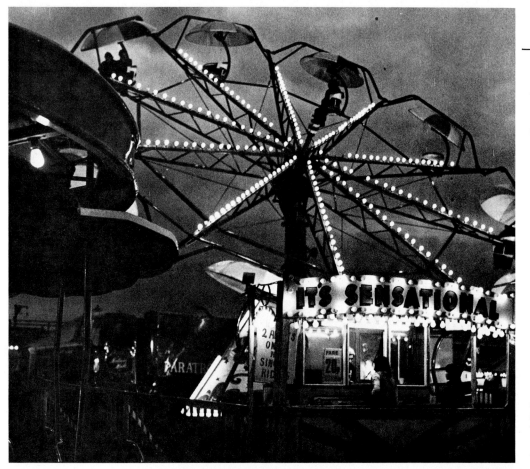

◀ Kodak Royal-X Pan 120 film, which has a normal speed rating of ISO 1250/31°, was exposed at EI 6400 and developed in Kodak DK-50.

▶ Tungsten-balanced slide film exposed at EI 800 accentuated the blue of the sky and the atmosphere of the fair at dusk, while at the same time reproducing the light bulbs in natural-looking colors.

▼ For this photo, ISO 400/27° color slide film was rated at EI 800. The first-development time was increased to nine minutes to compensate for one step of underexposure.

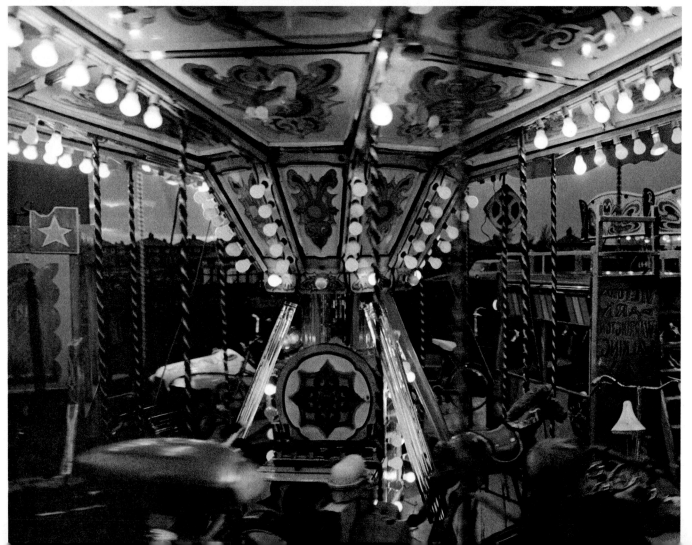

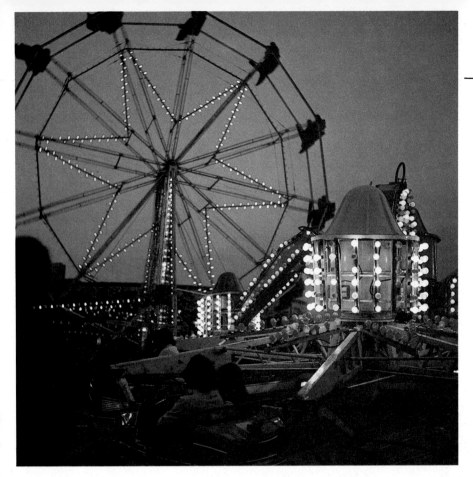

PULL-PROCESSING

Push-processing is giving increased development to compensate for underexposure. *Pull-processing* is the opposite—giving reduced development to compensate for overexposure. This technique is especially useful when you're photographing very contrasty scenes, such as lit buildings at night.

With normal developers, rate your film at 1/4 its normal speed, and develop for half the normal time. This enables you to record the most contrasty daylit scenes you're likely to encounter. For a nightscape like the one shown, expose Kodak Tri-X film for 10 seconds at *f*-5.6—with the camera on a tripod, of course—then develop the film for 8 minutes at 86F (30C) in Perfection XR-1 developer, mixed 1-1/2 level measuring teaspoons to 16 ounces of water.

These speed ratings, exposures and development times will put you "in the ballpark", but you may want to fine-tune them to suit your equipment, techniques and taste.

complicated processing involved. Therefore, use slide films designed for E-6 processing for pushing.

PUSHING COLOR NEGATIVES

Fewer labs will push-process color negative films than slide films because results of pushing color negative films are not as good. You can push-process your own color negative films—if they use the popular C-41 process—by developing for 4-1/2 minutes for a one-step push, 6-3/4 minutes for a two-step push, and 8 minutes for a three-step push. Other processing steps are normal.

If you push color negative film more than one step, the image is grainy and the colors soft and inaccurate. Unless you want special effects, don't push-process color negative film more than one step.

▶ This cityscape was exposed for 10 seconds at *f*-5.6 on Tri-X film. The negative was *pull-processed* in Perfection XR-1 developer as described in the text.

Grain Effects

Even though photographers normally try to minimize the appearance of grain in their photographs, emphasized grain can *enhance* photographs of some subjects. Several grain-enhancing techniques are available.

B&W GRAIN

Most of these are simple and easy:

Film Choice—Use a super-fast film such as Kodak Recording Film 2475, which has coarse grain because of its speed rating of EI 1000. You can push-process it to EI 4000 by processing it for 9 minutes at 68F (20C) in Kodak DK-50 developer. The resulting negatives will have grain that shows very clearly in an 8x10 print.

Special Film Processing—Push-processing high-speed films, such as Tri-X or HP5, will result in increased graininess. Extended development in a speed-increasing or a normal developer will increase both graininess and contrast. Be sure to expose the film at a higher-than-normal EI to avoid producing negatives that are too dense to print.

Printing Techniques—The greater the degree of enlargement, the larger the grain. But this doesn't mean that you have to make huge prints. You can make normal-size prints from a small portion of the negative.

Print exposure times can be very long with this technique, so negatives shouldn't be too dense. Otherwise, the times could be excessive. A condenser enlarger is good for grain effects because the focused light beam helps exaggerate grain.

For best results, the grain should be sharp. Make sure the enlarger doesn't vibrate during exposure, and check to see that the focusing mechanism is tight and secure.

High-Contrast Grain—Grain is more evident in high-contrast prints than in normal prints, so use a contrasty grade of paper, such as 4 or 5. For striking effects, enlarge the image onto Kodak Kodalith, or any other high-contrast (litho) film. They produce images consisting of only black and white tones, with no intermediate grays.

Kodalith is available in 35mm and most sheet-film sizes. Process it in special Kodalith high-contrast developer for best results. Most litho films can be handled under red safelight, so it's as easy to use as printing paper.

Reticulation—This is a distortion of the film emulsion caused by variations in the temperatures of the processing solutions. You normally avoid this by keeping all processing solutions at nearly the same temperature. To do it deliberately, put the fully processed negative in hot—110F (43C)—water for a few minutes, then plunge it into very cold water for a few seconds.

Reticulating a negative will ruin it for normal printing, so you should use copy negatives of the images you think will work well with this technique. Fix the copy negatives in a non-hardening fixer, then reticulate them as described. Prints made from reticulated negatives show a unique grain-like effect.

SHOOTING CONSIDERATIONS

You'll produce best results if you shoot your pictures with grain effects in mind. Large areas of even midtones show grain most clearly. In black areas of a print, the grain is so dense that it won't show clearly. White areas of the print contain little or no grain. Fine details or textures will mask

▲ Graininess can be increased by underexposing and push-processing fast films. Kodak Recording Film 2475 was exposed at EI 4000 and developed in DK-50. The resulting negative was printed on high-contrast Kodalith film to emphasize the grain effect in the above photo.

▶ Grain can also be increased by magnification. At right is a detail made from an EI 800 Tri-X negative that was greatly enlarged onto Kodalith film. Photos by John Evans.

grain, so avoid this type of subject.

GRAIN EFFECTS IN COLOR PRINTS

Producing grainy effects in color is more difficult than with b&w because extending development with color films adversely affects color balance.

Greatly enlarging a small section of an ISO 400/27° color negative or transparency will produce a grainy color print. Or, you can use a grain texture screen, as described on pages 16 to 19.

To use the grain texture screen, tape it to a sheet of glass that is slightly larger than the print you intend to make, then tape one edge of the glass to the enlarger baseboard. Make test strips without the texture screen to determine correct exposure and filtration for a normal print.

If the texture screen is used for the entire exposure, its effect will generally be too strong, so it's best to make part of the exposure without the texture screen in place. Then lower the glass with the screen onto the print to finish the exposure. Be very careful not to move the printing paper when you lower the grain screen onto it.

To control the grain effect, you'll have to experiment to determine the best ratio between the two exposures. For example, a long initial exposure used with a shorter second exposure produces weak grain. As a starting point, try giving the print an initial exposure that is 1/10 the correct exposure for a normal print. Then place the grain screen on the print. Make the second exposure five times as long as for a normal print—this compensates for the extra density of the screen.

There are also grain texture screens the same size as the negative. These are sandwiched with the negative in the enlarger's negative carrier when the print is exposed. You must use these for the entire exposure time, because removing or adding the texture screen without moving the negative is virtually impossible.

▲▼ A 22-second exposure produced the above Cibachrome print. To produce the grainy-looking print shown below, a three-second exposure without a screen was made to record some fine detail, then a 110-second exposure was made through a grainy texture screen. Photos by Andrew Watson.

GRAIN THROUGH A MICROSCOPE

With the help of a microscope, you can produce fascinating color grain effects and discover many new images in your old slides. The method is simple. Photograph a slide through a microscope strong enough to show individual grain clumps. This will often reveal fascinating details that are too small to be noticed in the original.

You'll need a microscope and an adapter to connect it to your camera body. Both are available at relatively little cost from the Edmund Scientific Company, 101 E. Gloucester Pike, Barrington, NJ 08007. Or, perhaps you can rent them at a large camera store or scientific supplier.

Don't use too high a magnification, because the more you enlarge slide details, the less sharp the image becomes. Try a 20X magnification with the microscope at first. Tungsten lamps are usually used as light sources with microscopes, so you'll have to use tungsten-balanced film to obtain good color balance.

Use a microscope to make a variety of pictures from one slide. Here, a small detail of the cityscape was enlarged 50X. Photos by Anne Hickmott.

Enlargergrams

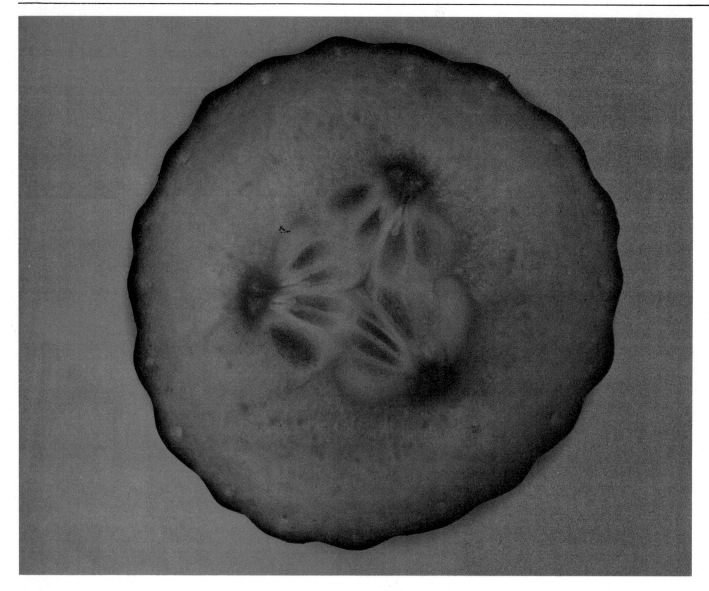

Most people make their color prints from color slides or negatives. But with an enlarger, some color reversal paper, and a few other simple materials, you can make *enlargergrams*.

Photograms have their limitations. You are limited to same-size images of your subjects, and only those parts of the objects that actually touch the paper are really sharp. Also, creating a design on color paper in total darkness can be difficult. You avoid these problems by making photograms with your enlarger.

WHAT YOU NEED

You'll need the same equipment you use for making color prints—an enlarger with dial-in filtration or a set of color printing filters, some color reversal paper, such as Cibachrome, and the chemicals to pro-

cess it, and a print-processing drum or a set of trays. You'll also need some 2-1/4x2-1/4 inch and 35mm glass slide mounts, and a few simple chemicals and translucent objects. For really spectacular effects, get a sheet of polarizing material.

HOW IT WORKS

To make an enlargergram, you place objects or chemical crystals in the enlarger in place of the usual negative or slide. You project an image of the material onto printing paper.

Position the objects to be enlarged on a 2-1/4x2-1/4 slide mount glass, and hold them in position there with another piece of glass or transparent tape. Then, compose the image on the enlarging easel. You can decide exactly how big an enlargement you want, and you can control sharp-

▲ You don't necessarily need a negative or a slide to make interesting color prints. You can use any object that transmits light and is small enough to fit in your enlarger. Photo by Lawrence Lawry.

ness to some degree by stopping down the enlarger lens.

For colors close to those of the original objects, use the same filter pack suggested by the paper manufacturer's instructions for printing Ektachrome transparencies. However, the way the print material responds to the colors of the object depends partly on the physical properties of the object itself, so your results may be unpredictable. Using a large amount of extra filtration helps add color to stark background areas.

SUBJECTS

You can use almost any nearly transparent material small enough to fit in your enlarger's negative carrier. Densely translucent subjects such as flowers and leaves usually require very long exposures, so avoid them. You can, with practice, use a razor blade to make thin sections of colorful fruits and vegetables.

For your first experiments, choose more transparent subjects, such as overlapping pieces of colored cellophane held together between two pieces of slide glass.

CRYSTAL PICTURES

Some of the most fascinating patterns can be made by letting chemicals crystallize on pieces of glass. Some useful chemicals include potassium bichromate, copper sulfate, chrome alum, iron sulfate, and sodium thiosulfate, which is also known as *photographic fixer.* Small quantities—enough for many experiments—are available in inexpensive chemistry sets sold in toy stores.

To crystallize these chemicals, make a saturated solution by dissolving as much of the chemical as you can in a small quantity of hot water. When a hot solution has more chemical dissolved in it than it can hold if it were cold, it's saturated. When a hot, saturated solution cools, crystals form.

Use an eyedropper to place a drop of saturated solution in the center of a clean 2-1/4x2-1/4 slide glass. Take a 35mm slide glass and allow one edge to rest on the larger glass near the drop of solution. Carefully lower the 35mm glass onto the drop. This spreads the drop to the edges of the smaller glass and, if you've been careful, excludes air bubbles. If the top glass were the same size as the bottom glass, the liquid might seep out.

As the liquid cools, it crystallizes. The form of the crystals may vary with the speed of cooling, so you may have to warm the glasses before use to slow

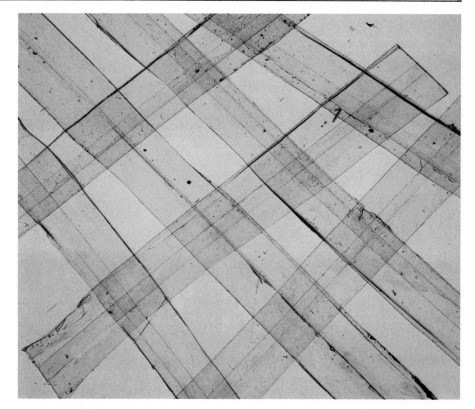

▲ Chris Kay stuck strips of transparent tape to a sheet of glass, which was inserted into the negative carrier. He enlarged the image onto color paper and used filtration to make this photo.

▼ Two sheets of polarizing material, one above and one below the negative carrier put unpredictable color into the same strips of tape. The colors vary where strips overlap. Photo by Chris Kay.

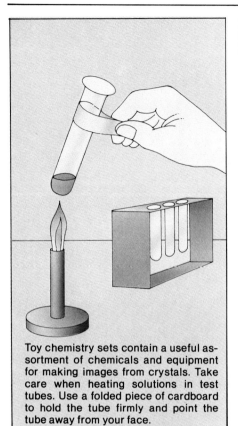

Toy chemistry sets contain a useful assortment of chemicals and equipment for making images from crystals. Take care when heating solutions in test tubes. Use a folded piece of cardboard to hold the tube firmly and point the tube away from your face.

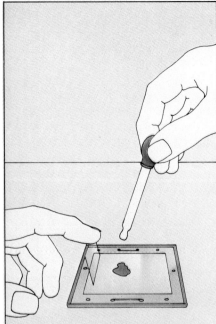

Use an eyedropper to put droplets of warm saturated solution on a piece of glass slide mount. Then carefully lower a smaller piece of glass slide mount onto the drop to spread out the solution without trapping air bubbles.

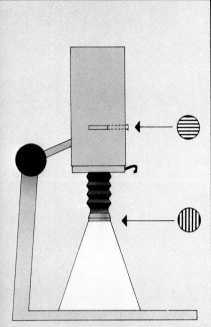

For the most interesting color effects, use sheets of polarizing material. Put one sheet in the enlarger's filter drawer, under any color filters being used. A second sheet should be under the lens. The polarizers should be "crossed"—see text—so that very little light is allowed through.

crystallization. Prepare several slides at once, varying the treatment of each. You can then place each slide in the enlarger in turn and examine the effect. When you see something you like, make a print of it within 1/2 hour, because the effect will change as the solution dries. Wash off unsuccessful attempts and re-use the glasses.

POLARIZED ENLARGERGRAMS

By using polarized light, you introduce vivid colors into the enlargergram. Cut a piece of polarizing material to fit your enlarger's filter drawer. Some color printing filters can depolarize light, so you want the enlarger light to pass through the color filters before the polarizer.

Cut another piece of polarizing material to mount under the enlarger lens. Be sure to keep this filter clean and free from fingerprints because a dirty filter below the lens can adversely affect image quality. You may be able to cut a circular piece from the polarizing material to replace the red safety filter built into your enlarger. You can also use the polarizing filter for your camera lenses.

Because enlarger designs vary so much, it's not possible to give precise instructions here, but regardless of the method you use,

you should be able to rotate the polarizer under the lens.

With both polarizing filters in position, but with nothing in the negative carrier, turn the enlarger on. Rotate the filter below the lens until light on the baseboard is minimized. You'll see just a dark blue light. This is the point of *maximum extinction*—the strongest polarizing effect. When you add a slide of chemical crystals, you'll see dramatic color patterns.

Use crystal slides or other materials to produce strong color effects with polarized light. Narrow strips of transparent tape overlapped on a piece of slide glass produce an exciting range of colors, as will many transparent plastics like crumpled cellophane.

KEEP NOTES

Because this is an experimental process, you should keep detailed notes if you want to repeat any effects. When printing crystals, record the strength of the solution used, whether the solution was applied to a cold or a pre-warmed glass, print exposure and any other special treatment.

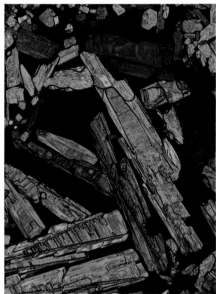

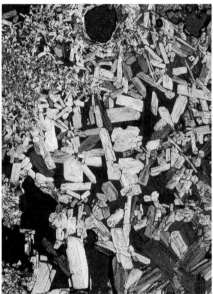

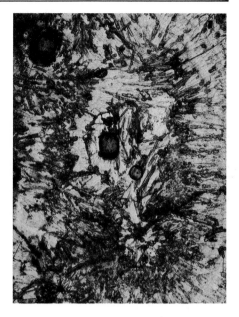

▲ Some ordinary chemicals found in photographic darkrooms will produce interesting effects when crystallized and enlarged onto color reversal printing material. Here, fixer crystals were cooled slowly on a slide glass and printed using crossed polarizing filters.

▲ For this photo, fixer chemicals were dissolved in warm water and allowed to crystallize on glass. But in this example, the solution was cooled rapidly. Thus many small crystals have formed. You can produce many different effects by varying the concentrations of the solutions and the rate of cooling.

▲ A saturated solution of potassium bichromate was dropped on a warm slide glass, and a few extra undissolved crystals were added to the solution before the cover glass was pressed down. No polarizer was used. Extra crystallization occurred around the undissolved crystals.

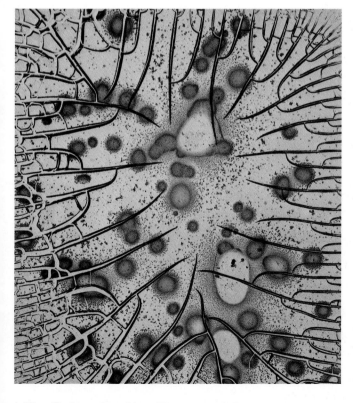

▲ The effects produced by adding some gelatin to the chemical mix are unpredictable. Here, a little powdered gelatin was melted with the chemicals and allowed to dry on the glass.

▲ For this circular image, crystals of Epsom salts and gelatin were left to dry for a few hours. Magenta filtration was used to intensify the color of the print. All photos on this page were made by Chris Kay.

Sepia Toning B&W Prints

Sometimes, you'll produce a b&w print that lacks visual impact—even though it's sharp, properly exposed and well-composed. You can often add impact by coloring the image with a *toner.*

Toners are available in a variety of colors, so you can choose just the right one to enhance your scene. For example, landscapes and portraits can look particularly warm and effective when toned brown, while blue toning can add the right touch to a snow scene or seascape. You can even tone some parts of your image and leave the rest untoned. The possibilities are endless.

This section shows you how to tone your image in *sepia*—a warm, rich red-brown. The next section shows how to tone the image in other colors.

PREPARATION

For best results with any toning process, you must first fully develop and thoroughly fix and wash the print. Otherwise, blotchy or uneven toning may result. Prints to be toned must be clean and contain no grease or retouching. And, print density and contrast should be suited to the particular toning process. For sepia toning, make the print *slightly darker* and *less contrasty* than normal, because this process reduces the overall density and increases print contrast.

▲ You probably have some portraits that can be enhanced by vignetting and sepia toning. To make a vignette, cut an oval out of black cardboard, and expose the image through the oval hole. Slowly move the mask during the exposure to produce a soft-edged image. You may want a warm brown-black instead of a full sepia tone. To produce this, shorten the bleach time with a two-bath toner or shorten toning time with a one-bath toner.

HOW TO DO IT

You can sepia-tone a print using a *sulfide toner,* which produces a warm tone. Or, you can use a selenium toner. You can use either method in normal room light. Sepia-toned images are more permanent than the original metallic silver ones. It's impossible to reconvert the sepia image—which is silver sulfide or silver selenide—back into metallic silver.

You can sepia tone your print using a two-bath method as shown in the step-by-step illustrations here, or with a one-bath method. Ready-made kits are available—two-bath sepia kits from Kodak and Berg, and single-solution selenium toner from Kodak.

The actual image color you'll get depends on three factors—the type of paper, print developer, and toner you use. Use chlorobromide papers, such as Kodak Ektalure and Agfa Portriga Rapid, for the warmest sepia tone. Single-solution selenium toners give warm tones with these papers only. Work in a well-ventilated area because some solutions give off unpleasant and potentially harmful odors.

One-Bath Process—In the one-bath process, you first presoak the dry print in water, then put the print directly into the toner. You don't use a bleach bath. This method, however, is much slower than the two-bath system. The complete one-bath process takes about 15 minutes.

Remove the print just before you achieve the right tone, because the process continues during the wash for a short time. With experience, you'll learn to judge when to remove the print from the toner.

You can tone prints as part of normal processing, after the final wash. Be sure to drain them well before you put them into the bleach or one-step toning bath. Otherwise, the excess water will weaken the solutions.

SEPIA TONING STEP-BY-STEP

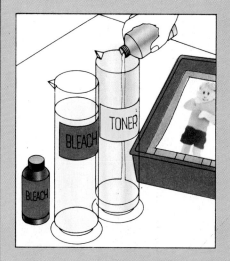

1) PREPARATION
Make sure that your work area is well ventilated. Read the instructions that come with the toner, then prepare the solution(s). Take care to avoid chemical contamination. Pour the bleach and toner solutions into clean, labeled processing trays, placed about 12 inches apart. Check that the print is free of fingerprints, then soak it in clean water for at least five minutes to soften the emulsion.

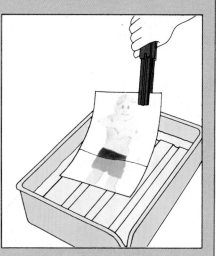

2) BLEACHING
Drain excess water from the print, then gently slip the damp print into the bleach bath. Agitate by rocking the tray. Continue until the image becomes straw-colored and almost disappears.

3) WASHING
Using tongs, carefully remove the print from the bleach bath. Thoroughly wash the print under running water for about five minutes. You must remove all bleach from the print.

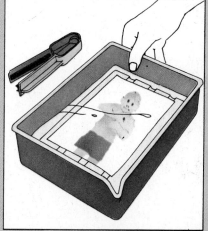

4) SEPIA TONE
After washing the print, place it in the tray of sepia toner. Agitate the tray by rocking continuously. The print should reach full density in about a minute, depending on the temperature and concentration of the toner. Using tongs, remove the print from the toner and wash thoroughly under running water for about 30 minutes. Dry the print normally.

▲ Photographer Jack Taylor decided sepia would be more effective than regular b&w tones for this candid shot.

◀ For this portrait in richly detailed surroundings, Amanda Currey used a sepia toner to warm the dark, slightly somber interior of the room.

▶ The warm tones of sepia are good for images that contain a lot of soft texture and patterns. Photo by Martin Riedl.

PARTIAL TONING

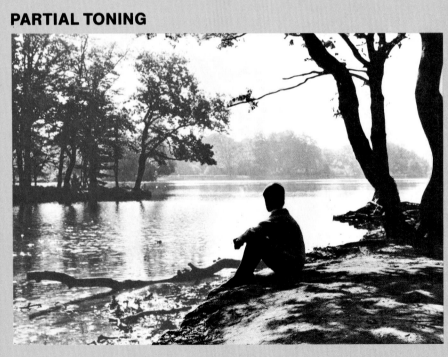

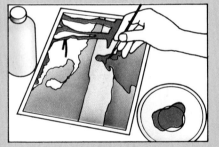

▲ Choose the image part you want to tone. Paint a maskoid solution over the rest of the print. Let the mask harden. Then you can tone.

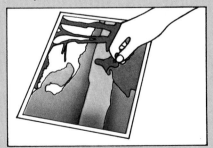

▲ You can tone just part of the image without affecting the rest of the print by applying a mask to the areas you don't want to tone. This technique is useful when you want to create a real and unreal mood in one print.

▲ Use a piece of sticky tape to lift the mask off the dry toned print.

Color Toning B&W Prints

When you have a b&w negative, you usually use it to make a b&w print. Perhaps you'll even tone the print a warm sepia or brown color, as described in the previous section. But there's no reason why you can't make a print of any other color if you think it makes the best print. The print will still basically be monochromatic—one color—but the color can be red, green, blue, yellow or another color.

An easy way to make colored prints from your b&w negatives is to use color toners. They work by changing the silver of the b&w image into an image of another color. The white base of the print stays white; the darkest areas take on a lot of color and remain dark. Therefore, toning is most evident in the range of gray tones between white and black.

HOW TONING WORKS

With all current toning processes, you first make a normally developed b&w print. Then you put the print through chemical aftertreatment to change its color. You'll find two basic types of toners.

One-Bath Toners—These work directly on the silver image of the print, turning it into a new chemical compound of a different color. One-bath toners act gradually, so you can watch the color build up while the print is in the toning bath. They're very easy to use, but don't offer as wide a range of colors as two-bath toners.

Multi-Bath Toners—These require extra processing steps. With the Berg Color-Toning System, for example, you first put the print in an activator solution, which readies the silver-based image to accept the color. Then you rinse the print and put it in the color bath. You can clear excess color from the paper base, if desired, by washing the print in water or using diluted household bleach. With the Colorvir Colorizing Kit, you put the print in the color toner, then into another bath, then into fixer. The exact procedure varies with the brand, but all involve more than one bath.

As mentioned, two-bath toners provide a wider range of colors than one-bath toners, and the Colorvir kit even yields multicolored and Sabattier-effect prints. But more steps are involved to do this—sometimes four or five chemical baths. All solutions are part of the Colorvir kit.

PAPER CHOICE

Most color toners currently available are intended for b&w resin-coated (RC) papers. However, some sepia toners don't react well with RC papers and produce very dark tones. You should use a fiber-base paper with these toners, but you may have to determine by experimentation whether a neutral image-tone paper such as Ilford Galerie or a warm-tone paper such as Kokak Ektalure gives the best results for your image.

Toners that work best with RC papers don't give the problems associated with toning fiber-base papers, such as the base white taking on color. Some toners work *only* with RC papers. Check the manufacturer's literature to see what paper types a given toner is recommended for.

MAKING PRINTS FOR TONING

When you make a b&w print you intend to tone, you should keep a few things in mind. The print should be developed normally and fully in fresh developer, fully fixed in non-hardening fixer, and washed thoroughly. You should use a washing aid before the final print wash to help ensure thorough washing.

Different toners do different things to print density while they change image color. Some darken the image, some lighten it, and some merely color it. The instructions generally tell you which is the

► The Colorvir Colorizing Kit from Edwal is a complete assortment of color toning solutions. You can color tone prints in a variety of ways for realistic or surreal results. A kit like the one pictured lets you tone hundreds of photos.

▲▶ A contrasty print, partially vignetted under the enlarger to give the effect of an old photograph, was partially toned so that good density and rich detail remain in the shadow areas.

case with a given toner, so you can make your print light, normal or dark to compensate accordingly.

COPPER TONERS

Copper toners produce brown, sepia or deep metallic copper tones, depending on the toning time and the paper being toned. With Berg Brown/Copper Toning Solution, 5 to 30 seconds in the toning bath will warm the image, 40 to 100 seconds will produce a brown tone, 2 to 5 minutes a sepia tone, 6 to 8 minutes a flesh tone, and 10 to 15 minutes a metallic copper tone.

RED TONERS

For red tones, you'll have best luck with red toners, such as Edwal's one-bath red toner, the two-bath red colorizers in the Colorvir kit, or the red toners in the Berg Color-Toning System. Copper toners will produce warm reddish-brown images if the print is left in the bath long enough, but such long treatment may degrade and lessen long-term image stability.

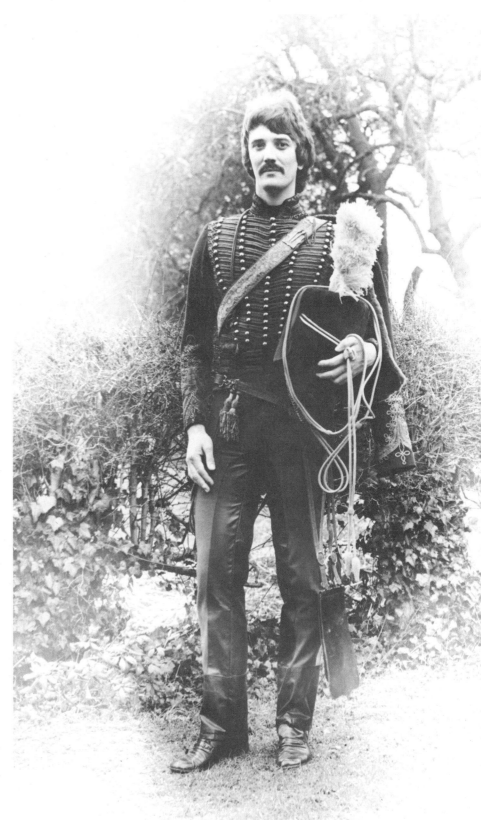

TWO-BATH TONING STEP-BY-STEP

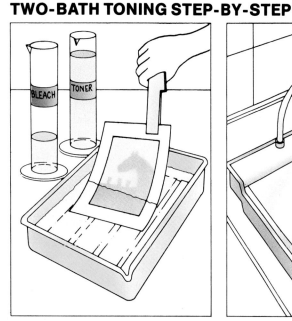

1) BLEACHING
Immerse the presoaked print in a bleaching solution. The image will become very faint in a few minutes. Use a weaker bleach solution if you want a partial toning effect in the final print.

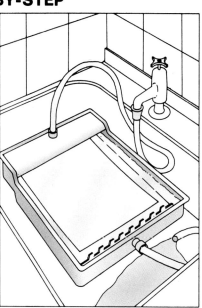

2) WASHING
After the image has faded, wash all traces of bleach out of the print with running water. The toning solution will not work properly if it is contaminated by the bleach, so be sure to wash the print well.

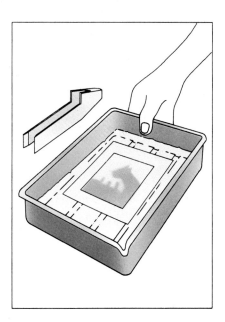

3) TONING
Put the washed print in a tray of toning solution and agitate gently. Use tongs, and handle the print by the borders only. If the emulsion is scratched, it may tone unevenly. Don't dip your fingers in the bleach or toner solutions.

4) DRYING
Wash the print again, then wipe surplus water from its surface and allow it to dry. Prints that have spent a long time in processing solutions have delicate emulsions when wet, so handle them with extra care.

YELLOW TONERS
Berg's Golden/Yellow Toning Solution and Edwal's yellow toner are good one-bath yellow toners. The yellow toners in the Berg Color-Toning System and Colovir kit are good multi-bath toners. With the Berg toner, a 5 to 10 minute immersion produces a golden yellow tone. By refixing the print you can change it to a purer yellow color.

GREEN TONERS
Green toners are available from Edwal, Berg and Colorvir. Each produces bright but somewhat different results, depending on the toner, solution strength and paper you use.

BLUE TONERS
Most blue toners are one-bath, iron-based solutions that produce a brilliant blue effect rapidly with all types of paper. Just immerse the print in the solution until you see the effect you want, then rinse the print in a very weak solution of normal stop bath. The toner has an intensifying effect, darkening the original image and increasing the contrast. Grain is also emphasized, so it's best to start with a soft, light print.

SPECIAL EFFECTS
Special effects are possible with some toners. With many of the Berg toners, for example, you can fully or partially reverse the toned image by redeveloping the toned print in paper developer. Briefly put the print in stop bath and wash it. No additional fixing is necessary.

With the Colorvir kit, and to some degree with some Berg toners, you can multitone the image by first bathing it in one color, then in another, as per the directions that accompany the solutions. Consider combining multiple toning with some other creative effects mentioned in this book.

SUCCESSFUL TONING
There are two common problems with toners—incomplete or patchy tone effects, and coloring of the white paper base. You can avoid both by following some simple rules.

Don't use old prints unless you have to. Prints tone best if they're freshly made. It's best to tone a print immediately after washing, before it has been dried.

Always fully develop prints for toning, even if they're low in density and contrast. Exposure should be the minimum necessary to avoid any trace of gray in the

▲ Color toning should suit the image—here, yellow gives an impression of desert sunshine. A two-bath toner was used to produce this yellow tone.

▲ A two-bath toner was used to give the tranquil greens of this print.

▲ A moody blue color was produced here by a two-bath dye toner. Single-bath toners will produce similar effects.

▲ Strong colors like this deep red are typical of Edwal dye toners.

▲ In comparison, the reddish-browns of this print are less garish. This effect was produced by extended treatment in Berg copper toner.

highlights, because this gray picks up color.

Stick closely to recommended times and temperatures with all toner kits, and always use acid or clearing baths if they're recommended. Many toners must be made up freshly and discarded after use. If you don't follow the directions, you might get poor colors, tinted whites and uneven toning.

Be particularly careful with RC papers. Don't touch the image area with tongs, because even slight abrasion of the emulsion surface may tone differently from the rest of the image.

To see what results various combinations of exposure and toning times produce, make exposure-test strips and tone them before toning a good print.

Finally, make sure the trays you use for toning are completely clean. If they're not, improper toning can result.

B&W Sabattier Effect

The Sabattier effect is among the most spectacular darkroom techniques. Some people mistakenly call it *solarization*, which is the complete reversal of the image due to extreme overexposure. Actual solarization is difficult to do with modern films.

The Sabattier effect occurs when a partially developed film or paper is re-exposed to light and development continues. The resulting image has both positive and negative parts. Where the two meet, there is a clear undeveloped line called the *Mackie line*.

CHOOSING AN IMAGE

Generally, well-defined, hard-edged, detailed subjects such as profiles or buildings are best. The subject should be lit from the side so there are well-defined shadow and lit areas. The lighting should be dramatic, but not too contrasty. Avoid evenly lit subjects because they won't have enough tonal contrast.

SUITABLE MATERIALS

Any size or type of film or paper can be used for the Sabattier effect. Slow, fine-grain films generally give better results than fast films. For example, Kodak Plus-X and Ilford FP4 are preferable to Tri-X and HP5. With papers, the greater the contrast the better—use grades 4 or 5, or an Agfa grade 6 if it's available.

FILM EFFECTS

Producing a conventional negative of top-quality takes experience and care. You must consider subject brightnesses, exposure and development—and make the right decisions about each. In Sabattier effects with film and paper, two more factors exist—re-exposure to light and redevelopment. For this reason, don't be upset if your first results aren't successful. The third or fourth attempts are usually more rewarding.

When working with 35mm film, you don't have to expose a whole roll for each test. Instead, shoot a suitable number of frames—perhaps 6 to 10—and cut these off the roll in the darkroom or a changing bag.

There are several ways to get the effect on your exposed film. Here are two.

SAFELIGHT METHOD

For this, you'll need a timer, a thermometer, a processing reel, trays for your processing solutions, and a 15-watt red safelight. Any good *paper developer* at its recommended dilution is suitable. You can use your normal stop bath and fixer solutions too.

Arrange the containers in the following order—developer, stop bath, water, and fixer. The working temperature of the solutions should be 68F (20C), and there should be enough of each in separate tanks to cover the processing reel. The safelight should be no more than about three feet away—a ceiling safelight won't do. When you've laid everything out and know where it is, you can turn out the room lights and begin. Follow the step-by-step instructions illustrated on page 57.

Agitate the film in the developer continuously, up and down, for 2 to 2-1/2 minutes for ISO 125/22° films, or 3 to 3-1/2 minutes for ISO 400/27° films. After the stop bath and re-exposure steps, rinse the film in water.

Redevelop the film for 2 more minutes, then follow with the normal sequence of stop bath, fixer and wash. The dry film should now show the effect of re-exposure and development.

WHITE-LIGHT METHOD

This is a sheet-film method adapted for use with roll films. After exposing the film, allow 2 to 3 inches of extra film when you cut the roll. Clip each end to the rim of the solution tray, making sure the film bows into the center. Use Kodak HC-110 developer diluted 1 part to 16 parts of water, at 68F (20C).

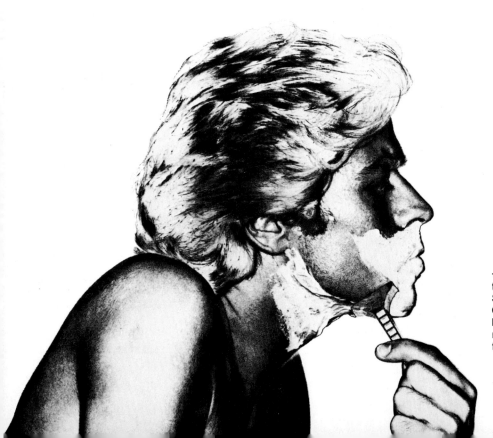

◀ If you choose the right subject and control light, you can create an effective Sabattier-effect negative. This is what Graham Hughes did to make the portrait of Robert Palmer. The print made from the negative has both positive and negative tones.

MAKING A SABATTIER-EFFECT NEGATIVE STEP-BY-STEP

1) LOADING THE REEL
After you've exposed 6 to 10 frames, open the camera back in the dark. Press the rewind button and lift the film up from the gate an inch or so. Slide scissors between the film and camera and—being careful not to stab the shutter curtain—cut off the exposed film. Put it on a processing reel and place it in a light-tight container.

2) DEVELOP
Arrange your processing solutions in the order in which you'll use them. They should be at 68F (20C). Turn off the room light and put the reel into the paper developer. Agitate with a continuous up-and-down motion.

3) STOP BATH
When first development is complete, transfer the reel to the stop bath and agitate continuously for a minute. A string handle makes agitation easier.

4) RE-EXPOSE
Remove the film from the reel and expose to the safelight for 20 to 30 seconds at a distance of about 3 feet, emulsion side toward the light source. Take care that the film does not drip on any electrical connections.

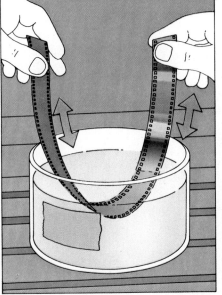

5) WASH
When the second exposure is complete, turn off the safelight. Hold the film at each end and see-saw it through the wash water, making sure the full length is rinsed. This removes the remaining stop bath.

6) REDEVELOP
Redevelop the film for 2 minutes in the paper developer. Finish processing with the normal sequence of stop bath, fixer, washing and drying.

◀ The subject and lighting shown at left typifies a good subject for the Sabattier effect. A negative made normally was enlarged onto high-contrast film, which was developed and re-exposed as described. The Sabattier-effect image was then contact printed on another piece of high-contrast film, and this image was enlarged onto paper. Photos by Richard Brook.

Pour the developer into the tray and agitate it by rocking continuously from side to side for 1 minute 20 seconds. Leave the tray still for 10 seconds, then expose it to white light—from an ordinary bulb or an enlarger—while the film is still immersed. Try an exposure time from two to five seconds with a 15-watt bulb about three feet away, or the equivalent. With an enlarger, you can give stepped exposures like a test strip if the film is protected from stray light reflecting off the bottom of the tray.

After exposure, agitate again until the film has been in the developer a total of 3 minutes. Then proceed with normal stop bath, fixing, washing and drying.

JUDGING RESULTS

Sabattier-effect negatives are very dense, so don't panic when you first see your processed film. The negative image

from the camera exposure and first development is usually neutral gray in color, while the positive image from the second exposure and redevelopment is warmer and creamish in color. Inbetween the images you should see the clear Mackie line. With luck, both positive and negative images have adequate detail and contrast, and the lines between them are clear. You can print this kind of negative.

With the first attempt, the problem is usually to decide what went wrong. Remember that the density of the negative is due to exposure; contrast is due to development. Because the first exposure was made normally in the camera, it's not likely that there will be detail lacking in the neutral-tone negative image. This image might be too flat or too contrasty. If so, you should increase or decrease first development by 1/2 to 1 minute on your next test roll.

It's much more likely that the positive image is faulty. To correct it, apply the same thinking, but to the re-exposure and redevelopment. Increase density by a longer exposure, and decrease it by a shorter one. Correct too much or too little contrast by decreasing or increasing second development time.

Sometimes, Mackie lines are not very clear. This can occur when the original scene doesn't have well-defined boundaries between light and dark areas. If this is the case, you'll be wasting your time. Choose another subject or image. If the subject is suitable, the Mackie lines can be improved by reducing agitation during both developments. Agitate for the first half of the time, then let the film remain still for the second. To compensate, increase total development time by 20%.

PRINT EFFECTS

Getting the Sabattier effect in a print during processing is difficult if you aren't careful in using a suitable image and correct re-exposure. As with film effects, images with vivid tonal boundaries work best. Otherwise, you'll lose too much fine detail.

To get the effect in a print, first expose your negative onto a sheet of printing paper in the normal way. Halfway through development, when the print in the developer tray is clearly visible, re-expose it to white light. You'll find an enlarger useful here, because the aperture allows fine control of the brightness of light. Overexposure is the most common cause of failure in Sabattier-effect prints.

When you use the enlarger for re-exposure, move the tray holding the print to the enlarger baseboard. Be careful not to spill solution. As soon as you see a change in the image, turn the light off. Because the paper is still in the developer, the image will change rapidly, so you'll need to transfer it quickly to the stop bath. Finish processing the paper normally.

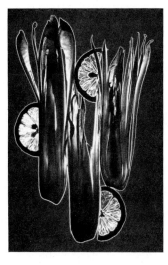

▲ A Sabattier-effect negative is denser than a normal negative.

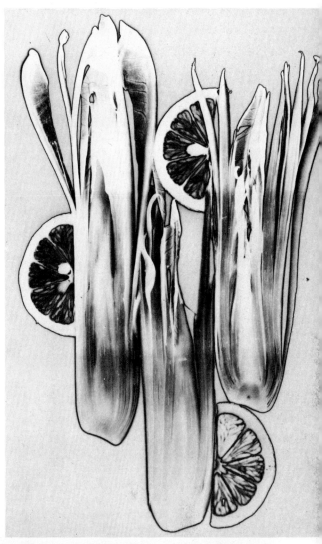

▶ The still-life subject was lit from below. When the film was given Sabattier treatment, a Mackie line developed between the light and dark areas. This produced an interesting outline around the elements. Photo by Heino Juhanson.

▶ The flat, metallic look of a Sabattier-effect print works well with this image.

Color Sabattier Effect

As you've just learned, b&w Sabattier effects are composed of positive and negative tones. With color materials, colors complementary to the originals are also created—yellow replaces blue, magenta replaces green, and cyan replaces red—when white light is used to make the exposure.

The colors produced are so unnatural that it doesn't matter whether you start with a color slide or negative. Therefore, let's define the color image you start with as the *original color image.*

MAKING TRANSPARENCIES

To get the effect in a color transparency, use a *print film.* It's a color print emulsion coated on a translucent film base. It's normally used to make color transparencies from negatives. The Kodak version, Vericolor Print Film, is developed with the C-41 process used for color negative film. The print film is available in sheet form only. Order boxes of 4x5 inch size through your local camera store.

MAKING AN EXPOSURE GRID

You must make a special type of test strip, because two exposures are necessary, and the relationship between them is important.

Working in total darkness, take a sheet of print film from its box and place it emulsion side up on the baseboard under the enlarger head. Place the original color image emulsion side down on the print film, and cover the two with a sheet of plate glass that will keep them flat. If you're working with 35mm originals, six will fit well on a 4x5 sheet of print film. Make a test strip as you normally would when making a color contact sheet, keeping the covering cardboard sheet square to the film.

Process the film sheet in small trays standing in a larger one, which acts as a water bath to maintain the recommended solution temperature.

Use enough of each solution to ensure that the film sheet is completely covered—there's no way of checking this visually when you begin. Tongs are impractical when you work in complete darkness, so wear plastic or rubber gloves for handling the materials. Because color developers are extremely irritating to the skin, such protection is always necessary.

Re-Exposure—After making the first series of exposures, slide the sheet of film into the developer. Be sure to handle the film without delay, because development time is short. Halfway through development, remove the sheet and, sup-

porting it on a sheet of glass to keep it flat, make a second series of test-strip exposures, each twice the length of its equivalent in the first series, and at right angles to the first set.

You should use a 30-watt bulb about five feet from the film to make the second series of exposures. Filters can be used to color the light source—any strongly colored filters will do. Varying the color of the second-exposure light source will create unusual and exciting effects.

Second Development—Return the film to the developer and complete processing in the usual manner. When the film dries, the grid produced will show all the possible variations. You can select the combination of variables you prefer.

If you don't care for any of the grid segments, make another test with a different filter over the second-exposure light source, or with a new original color image. When you've found the exposures that you prefer, the film can be left in the developer during re-exposure. The results of this technique will feature strong colors, but their range will be limited. Highlights are strongly colored.

▲▼ An ordinary color slide or negative can become the basis of a striking color Sabattier-effect image. For the image below, a pale red filter was used for the re-exposure.

▲ The original color image need not be boldly colored. But it should be an interesting composition with clearly defined patterns.

▲ Right: This simple color image was made with re-exposure from an ordinary light bulb. Using the enlarger to make the re-exposure would give you better control.

▶ You can produce subtle and varied effects by using color filters in the enlarger for the re-exposure. Here, a pale red filter was used, along with a neutral-density (ND) filter to prolong the exposure slightly.

▼ The process is taken one step further by printing the Sabattier-effect print film directly onto another sheet of print film without further manipulation. This reverses the colors of the image.

PRINT EFFECTS

The simplest way to get the Sabattier effect in color prints is similar to the b&w-print method. Give the print a slightly curtailed first exposure and place it in the developer. One-third of the way through development, make the second exposure to a white or colored light source while the print is in the tray. Make a test grid as described to get different exposures.

Although simple, this method is difficult to control, and the results, relative to those of other methods, are rather crude. An alternative method, which gives much more control over the result, requires tri-color filters.

USING TRI-COLOR FILTERS

Tri-color filters are of pure primary colors. Kodak Wratten filters No. 25 red, No. 47 blue and No. 58 green can be ordered through your camera dealer. When a tri-color filter is used over the light source during the second exposure, only one layer of the paper emulsion is affected.

Start by making a normal color print of the original color image to determine exposure time. When you've done this, put a sheet of glass on the printing easel and refocus the image onto a plain sheet of paper. The glass will protect the easel from chemicals during re-exposure of the partially developed print. Stop the lens down to the aperture used to make the normal print, then make the first exposure, reducing exposure time by about 15%.

Remove the original color image from the negative carrier, and tape one of the tri-color filters under the enlarger lens. Begin developing the print in the tray. Halfway through development, remove the sheet of paper from the developer and place it on the glass, registered with the projected image as well as possible. Make a second exposure for the same time as the first, return the paper to the developer, and complete the processing sequence.

If you encounter difficulties, make a test grid to determine the exposure more accurately. And don't drip any developer on electrical connections or switches near the enlarger.

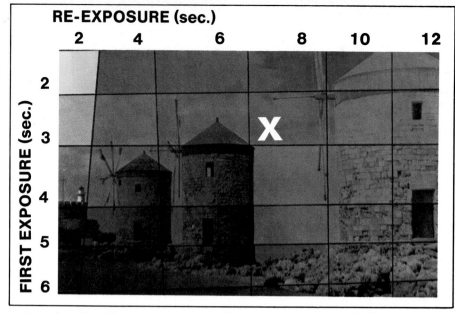

▲ Color Sabattier effects don't have to be based on trial and error. Making an exposure grid lets you see the effect of the secondary exposure precisely, as represented by the X.

COLOR SABATTIER EFFECT STEP-BY-STEP

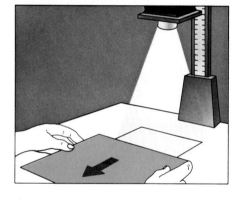

1) TEST STRIP
You can make an exposure grid with any of the color Sabattier-effect techniques described here. The first step is to make a test strip, giving shorter exposures than usual. Try to keep the card square to the paper or print film, and make steps of equal width.

2) DEVELOP
Processing must be done in a tray. Make sure the tray is at least one size larger than the material being processed, and that there's enough of each solution to completely cover the material. Agitate it continuously by gently rocking the tray.

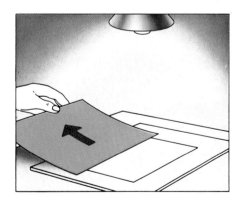

3) RE-EXPOSE
When development time is half over, remove the paper or film from the developer and immediately support it on a sheet of glass. Make the second series of exposures at right angles to the first series.

4) FINISH DEVELOPING
When you've finished the second series of exposures, immediately return the material to the developer and continue with the normal processing sequence, according to the manufacturer's directions.

RE-EXPOSURE WITH THE ORIGINAL

This is a variation on the tri-color method. Make the first exposure as before and begin development. Tape a filter under the lens, but leave the original color image in the negative carrier. Halfway through development, remove the paper from the tray and place it emulsion side up on the glass sheet.

Soak a piece of cotton in developer and swab the paper flat. Turn the enlarger on and quickly align the half-developed image with the projected image. Swab the paper continuously with developer until you see an effect you like—you'll need some trial-an-error experience before you can judge the image accurately. When you see what you want, turn off the enlarger. Remove the print from the glass, quickly put it in the bleach-fix, and complete the processing.

USING A LIGHT MASK

This third variation involving tri-color filters will produce white highlights. Contact print the original color image onto high-contrast film such as Kodalith to get a relatively equal amount of black and clear areas.

Make the first exposure as before and begin development. Tape a tri-color filter in place under the lens, and replace the original color image with the mask. Halfway through development, remove the print and swab it flat onto the glass. Then turn the enlarger on and align the projected mask image with the image on the print. The second exposure should be approximately half of the first one. Complete processing as usual.

▲ Strong patterns made by photographing New York's World Trade Center from a low angle were combined with the unrealistic colors of the Sabattier effect to create this bold, abstract image.

▶ The Sabattier effect can make even an ordinary color image an exciting and vividly colorful picture.

High-Contrast Images

For an exciting graphic effect, consider making photographic images with just stark blacks and white tones—no intermediate grays. You do this by increasing contrast so much that gray tones are eliminated. The resulting bold shapes and patterns are often striking.

USING A HIGH-CONTRAST ORIGINAL

One way to get high-contrast pictures is to expose ordinary b&w film and develop it to high contrast. This might seem to be the easiest procedure, but it isn't. You must light the subject to provide full modeling and adequate contrast—this generally means using strong side lighting. Choose subjects with simple and clearly recognizable shapes.

Underexpose the film two to three steps, or even more—for example, expose ISO 125/22° film as though its speed were EI 600 or more. This underexposure records only highlights in the subject. Increase development time about 50% for every doubling of the film speed. Don't be disappointed if your first images are not what you expect. Experience will improve your results.

USING A HIGH-CONTRAST DUPLICATE IMAGE

This method involves copying an original negative onto an extremely high-contrast negative material, such as Kodak Kodalith Ortho film, Type 3. This film comes in 35mm size in 100-foot rolls, and in sheet film sizes up to 8x10 inches.

Litho films are made for the graphic-arts industry to provide extremely sharp high-contrast images for printing-press reproduction. Most litho films are *orthochromatic*—sensitive to blue and green light, but not to red. Therefore, you can use a red safelight while exposing and developing them.

However, if you wish to use color transparencies as originals, you must use panchromatic litho film, such as Kodak Pan Film 2568, to get a proper tone rendering of all colors. Because panchromatic litho films are sensitive to light of all colors, you'll have to work in complete darkness.

Litho Developers—Litho films require special litho developers, which come in two parts, A and B. They're available in liquid and powder forms. Liquid types are easiest because the powder can be difficult to dissolve. As a rule, you'll mix equal parts of A and B solutions just before use, because the mixed developer solution deteriorates quickly. Tray life of the mixed solution is about an hour. Separately, in closed bottles, the solutions will keep for a few months.

Exposure—The technique is simple. Contact print the original negative onto a piece of litho film to get a high-contrast positive transparency. Choose an original that has good detail and modeling. To find the right exposure, make a test strip. Even with the small 35mm frame, you can fit at least three test steps per frame.

Use a sheet of glass or a contact-printing frame to hold the original and the litho film in good contact. Contact print the two films emulsion to emulsion. If you use glass, put a piece of black paper under the film to avoid reflections from the white base of the printing frame. Film manufacturers normally don't give a film speed for litho material, but you can figure on it being about twice as fast as printing paper.

Unlike most test strips, the one produced by this technique will not consist of different densities. Here, the different exposures produce varying areas of black. The longer the exposure, the more of the original image is converted into black. It's up to you to choose the proportion of black that you think is most appropriate for your image.

Processing—Develop the litho film in a tray for 2-3/4 minutes at 68F (20C). Try to keep the temperature constant, because litho developer is sensitive to temperature variation. Agitate the film continuously for the first 15 to 20 seconds, then leave the tray still for the rest of the time. Still-

▶ Sometimes, making a high-contrast image adds to the atmosphere of a picture. Here, the bleak and dismal appearance of the original subject is emphasized by the harsh contrast.

▲ When selecting images to turn into high-contrast pictures, look for bold shapes and simple subjects. These become easily recognizable and graphic.

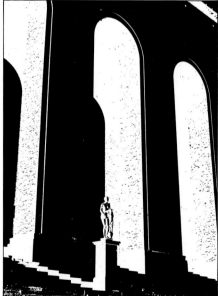

▲ Because turning the image into just black and white creates a very artificial image, the negative version can often be as effective as the positive version.

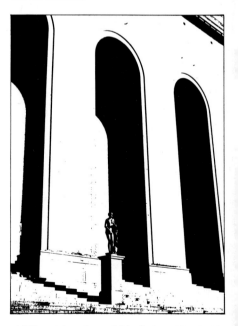

▲ The proportion of black to white in the image depends on exposure. The longer the exposure, the greater the amount of black in the high-contrast picture.

bath development produces best sharpness. You can put the red safelight near the developing tray—if you're using regular litho film. Work in the dark with panchromatic litho film.

After development, rinse the film for about 10 seconds, fix for 2 or 3 minutes in your normal film fixer, and wash and dry in the same manner as other films.

To produce a litho negative, contact print the dry litho positive onto another piece of litho film. This time, test to find the minimum exposure that will produce solid blacks through the clear areas of the positive.

Printing—When you print the litho negative or positive, you can use a normal-grade paper. Correct exposure is the minimum required to produce solid blacks through the clear areas of the negative.

AVOIDING PROBLEMS

Your main enemy is dust—you can't be too clean. Litho film, due to its good sharpness and contrast, shows the tiniest spot of dust, even if it wouldn't show on a normal film.

One way to deal with dust—if your equipment allows it—is to work with a larger format than 35mm. If necessary, enlarge the original negative to make bigger positives. It's easier to retouch the blemishes on a larger image.

If you should get some slight fogging—which can be caused by using old film—don't despair. Farmer's reducer will remove the fog. The black image on lith film is dense enough to withstand a lot of reduction.

PEN-AND-INK DRAWINGS ON PRINTS

If you'd like to make a pen-and-ink drawing of a complex subject, such as a landscape, but don't have the skill to do it, here's a way photography can help.

Make a very flat, low-contrast b&w print showing all the required detail. Use a low-contrast, grade 0 or 1 paper, and develop for only one minute or less. Make sure there are no blacks or dark grays in the print. It doesn't matter if the print is slightly uneven due to reduced development. Fix the print, give it a short wash—five minutes will do—and dry it.

Now, draw in or outline on the print the relevant detail with waterproof ink or other indelible marker. Let the ink dry well. You now have a pen-and-ink drawing on top of the photographic image.

The next step is to eliminate the photographic image with Farmer's reducer. If

▲ Old buildings with ornate shapes and plenty of fine detail can make a suitable high-contrast photo. However, you must choose exposure carefully so not too many details turn black.

the image is light enough, you'll have no problems. The easiest way to do this is to fill a tray with the reducer to a depth sufficient to cover the print. When the photographic image has gone, fix the print once more to make sure no silver halide is left in the emulsion. Wash and dry the print.

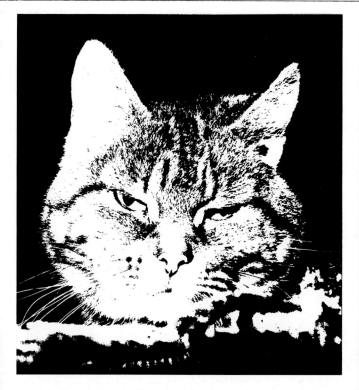

▲ Although high-contrast prints do not have gray areas, stippled areas of fine, contrasting detail, such as shown in the cat's fur, provide contrast to the solid areas of white and black.

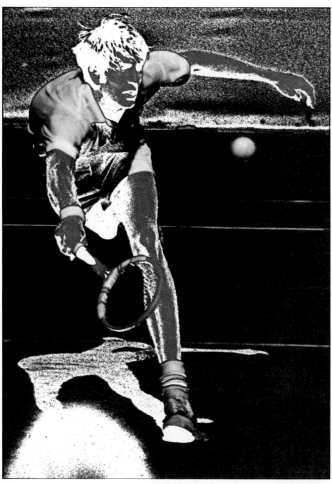

You'll find it best to use matte or other non-glossy papers that take ink well. On glossy paper, ink tends to flake off, and most waterproof felt-tip pens tend to smear. They require very careful and delicate handling in the reducer and in subsequent fixing and washing.

If you need many copies, you should make the first image about twice as large as the desired final size, then copy it with the camera and make your copies from the copy negative. This helps to camouflage imperfections in the drawing, because they'll be reduced in size and less noticeable.

▲ Use litho film as a mask to give unusual effects with color film. Fred Dustin sandwiched a litho positive and a color negative to make this photo.

◀ The graphic shapes created by line work make eye-catching illustrations. Add a small spot of color with an indelible marker to emphasize the broad black areas.

B&W Posterization

In posterization, the original picture is separated into distinct tones. It simplifies an image like contours on a map simplify the original landscape. Posterization is an elaborate darkroom technique, requiring patience and skill. But it allows you to produce unusual and effective images, both in b&w and in color.

To understand this process, imagine continuous gray tones from white to grays to black in a b&w print. All possible tones are included. If you select fewer tones—white, light gray, dark gray and black—you have *tone separation.*

To get such a result in practice, you must eliminate most of the intermediate tones from an image. Normally, three or four tones are used for b&w posterization, but you can use more. Just remember that the more steps you create, the more the result resembles an ordinary continuous-tone photograph.

◄ You'll need a registration board for posterizations. Here white paper is on the board so you can see the negative. When actually using the board, put black paper under the negative to prevent light from reflecting back onto the film.

► The most striking examples of posterization are often those with sharply defined areas. Here the image is separated into bands of even tone that follow the shapes of the building.

▼ The original image should have a good tonal range. If not, it'll be difficult to make clear separations.

CHOOSING THE FORMAT

You can get good results with any film format, but as with other techniques, the larger the format, the easier it is to produce good results. If you have 4x5 or larger negatives, you may want to do all your work by contact printing. Otherwise, enlarging smaller negatives to make separations is OK.

EQUIPMENT

The first things you'll need are a registration board and a matching punch, so you can register separation negatives precisely. Commercial ones are very expensive, but fortunately you can get and make substitutes. An ordinary paper punch from a stationery store will do, and you can use two wooden pegs that exactly fit the punch holes to make a registration board. Find the wooden pegs or doweling at art- and model-supply stores. The pegs must fit the holes snugly, with no play and no tearing of the holes. A few minutes of sandpapering will get this right. The pegs should be about 1/4 inch high or a bit more, and slightly rounded on the top.

Attach the pegs to the registration board. It should be somewhat larger than the film you'll be using—about 4-1/2x6 inches for 4x5 inch film. Paint or color the top surface black, or glue a piece of black paper or cloth on it. This prevents light from reflecting back through the film base.

You'll also need a sheet of clean glass at least 1/4 inch bigger all around than the largest size film you'll be using. Get a pair of scissors to cut test strips, a magnifying glass or loupe, and a red safelight.

CHOOSING THE MATERIALS

You'll need two kinds of film to make posterizations—a high-contrast film, such as Kodak Kodalith Ortho Type 3, and an orthochromatic continuous-tone film, such as Kodak Fine Grain Positive film 7302. Both are available in 4x5 sheets. You'll also need litho developer for the litho film. With these materials you make the *separations.* You can develop the continuous-tone film in print developer, which works more rapidly than most negative developers.

SUITABLE SUBJECTS

Pictures of people are rarely enhanced by posterization, but landscapes, animals, building, or many other subjects will work. You'll find it easiest to work from a negative that has a full tonal range and good modeling, and slightly greater contrast than normal.

POSTERIZATION STEP-BY-STEP

MAKING POSITIVE SEPARATIONS

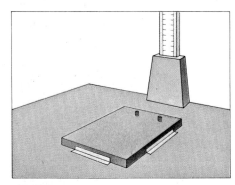

1) SETTING UP
When you've chosen a negative, place the registraton board on the enlarger baseboard and focus the image. When you're satisfied, tape the registration board firmly in place. If it moves at any stage, you'll have to start all over again.

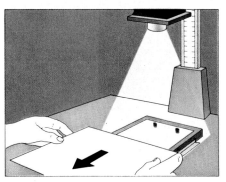

2) TEST STRIP
Don't try to make too many test steps on one sheet of film. If you don't get the range you want at first, make another test.

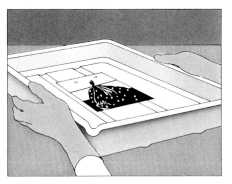

3) PROCESSING
When processing the litho film, rock the tray continuously for a while then let the film develop without agitation, as described in the text.

MAKING THE POSTERIZED NEGATIVE

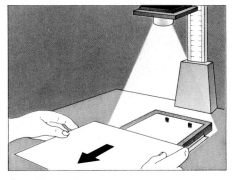

1) TEST STRIP
To calculate exposure for the posterized negative, make a test strip on continuous-tone film without any film in the negative carrier.

2) TEST RESULTS
The first step of the test film should be a very pale gray, the third a middle gray. If they are not, dilute the developer and retest until you're satisfied.

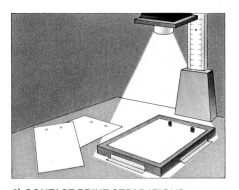

3) CONTACT PRINT SEPARATIONS
Having found the correct exposure to give a pale gray, use it to contact print the three positives, one by one, onto a sheet of continuous-tone film positioned on the registration board.

POSITIVE SEPARATIONS BY ENLARGEMENT

Use an enlarging lens longer than normal, if you have one, because this ensures that the enlarger head is farther from the registration board. Exposure times are longer and more manageable.

Put a white sheet of plain paper on the black surface of the registration board, then place it on the enlarger baseboard. Project the image onto the white paper, crop and scale as desired, then tape the registration board firmly to the baseboard to prevent any movement.

Exposure—Next make a test strip. To avoid wasting film, cut a sheet of 4x5 litho film in half lengthwise. Punch holes in it so that it can be firmly positioned on the registration board. Make your test exposures, then process the test film in litho developer for 2-3/4 minutes at 68F (20C). Your goal with the test strip is to find exposures for three different positives. On the first, only the shadow areas should be black. The second should record half the middle tones as black. In the third, everything except the highlights should be black.

When you know the exposures necessary to produce these results, take three full sheets of litho film and punch registration holes in each. Fit each in turn on the registration board, and give each the determined exposure time.

You can place small coins on the free corners of the film to hold them flat. Process these films exactly as you did the test strip.

POSITIVE SEPARATIONS BY CONTACT

If you want to contact print to make positive separations, use the enlarger as your light source. Cut a 1-1/4-inch-wide strip of sheet film and tape it edge-to-edge to one end of your original negative. Punch two holes through the strip of sheet film so that it can be positioned securely. Cut a piece of litho film in half and place it, emulsion up, on the registration board.

Place your original negative, emulsion down, on top of the litho film, cover with glass—but not the pegs—and make a test strip. From the result, select the three

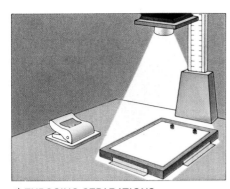

4) EXPOSING SEPARATIONS
When you've selected the three exposures, punch holes in three sheets of litho film. In turn, place each sheet on the registration board, and give each sheet one of the exposures calculated fom the test strips. Process as before.

4) RESULTS
The posterized negative is composed of four different densities. Three are produced by the three exposures. The fourth is clear because those areas were covered during every exposure.

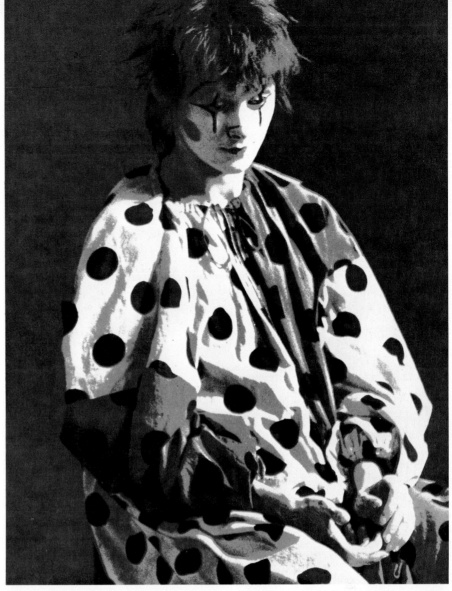

▼ The three positive separations below were used to make the posterized negative. Clear tonal differences in the separations are necessary for a good final result.

▲ Having printed the separation positives onto one negative, you need only enlarge this negative like any other to make the final print, as above.

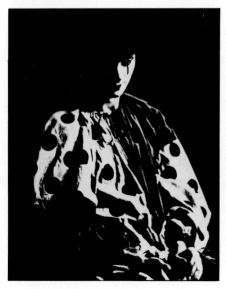

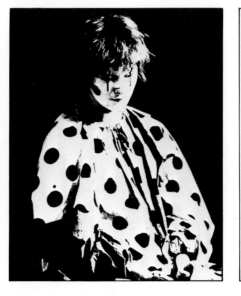

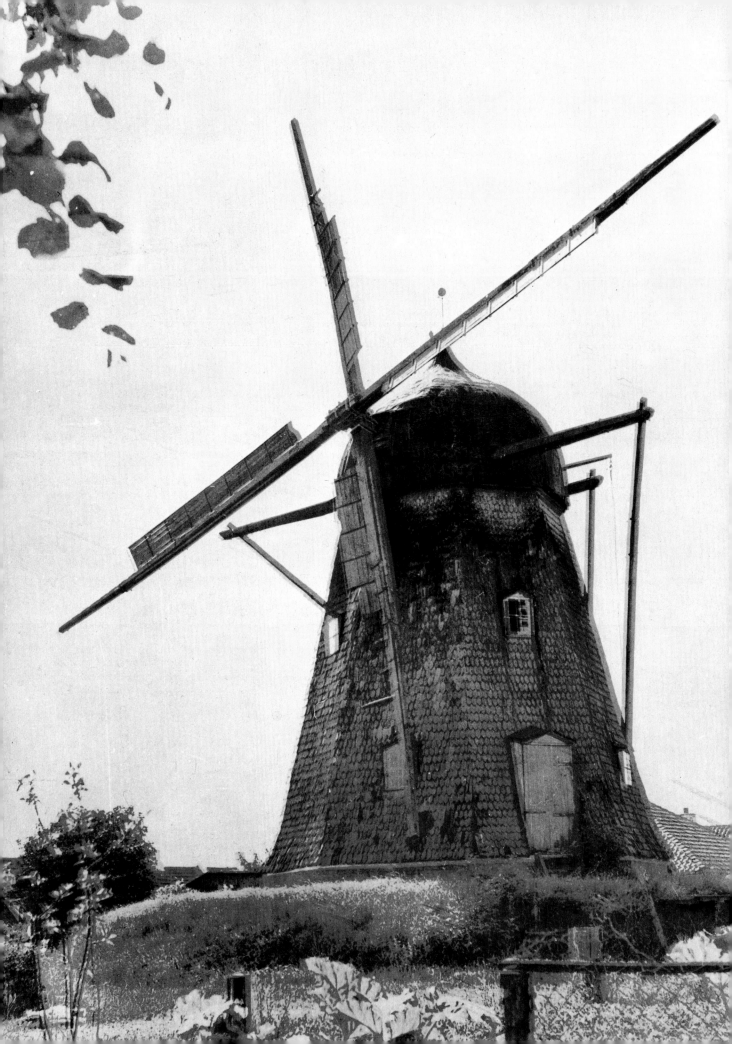

exposures that produced the three different areas of black image decribed in the preceding section.

Using these three exposure times, make your three separation positives. To do this, punch registration holes in the three pieces you intend to use. Fit one litho film sheet on the registration board emulsion up, and fit the original negative, still attached to the punched strip of sheet film emulsion down on top of it. Cover with glass, and make the first exposure. Repeat this procedure with fresh film for the other two exposures, and process as before.

RETOUCHING THE RESULTS

When you have a set of three separation positives, check them with a magnifying glass for dust spots. Any pinholes in the black areas can be filled with opaque retouching material. Black spots in clear areas can be scratched out with a razor knife. If your images are 35mm, such work requires a lot of care.

CALCULATING NEGATIVE EXPOSURE

When the positives are made, either by enlargement or by contact printing, your next step is to make a series of exposures—without a negative in the carrier or the registration board—to produce a series of gray tones.

For this and for making the subsequent negative, use continuous-tone film, such as Kodak Fine Grain Positive 7302. It can be processed under safelight conditions.

Although the exposures necessary to give the desired results vary from enlarger to enlarger, you can use the following as a guide:

Raise the enlarger head until the lens is about two feet above the baseboard. With a 75-watt bulb, and the lens stepped down to f-11 or f-16, the exposures should be about 2, 4 and 8 seconds.

Develop the sheet of film in print developer for 1-1/2 to 2 minutes at 68F (20C), agitating continuously. Rinse and fix in the usual way. The first exposure should

be a pale gray. The third step should be a mid gray, about the color of cigarette ash. If the scale is too dark, redo the exposure test with less exposure time or dilute the developer and retest. Don't alter density by changing development time.

MAKING THE NEGATIVE SEPARATION

When you're satisfied with the steps on the gray scale, punch holes in a sheet of the continuous-tone film. Fit it on the registration board's pegs and fit the first of the separation positives—the one with the smallest image area—on top of it. Remember, the films should be emulsion to emulsion. Keep the two films in contact by placing a sheet of glass on top of them—avoid putting the glass on the pegs.

Give the exposure that gave the pale gray tone of the test strip. Replace the first positive with the second, and give an exposure equal to the first onto the same sheet of film. Finally, replace the second negative with the third and make an exposure *double* the previous one, on the same sheet of film.

Now take the exposed sheet of film from the registration board and process it as you did the gray scale. When it's dry, the separation negative just produced will have four areas of different density—a clear area, which was covered during all three exposures; a pale gray produced by the first exposure; a dark gray area that was illuminated by both the first and second exposures; and a black area that was uncovered during all three exposures. You can print this negative in the normal way to produce your posterized print.

When you've mastered this technique, it's easy to move on to color posterization. Although the images are created on color paper, the negatives and positives are made on high-contrast b&w film. The color is produced by exposing through strongly colored gelatin filters. It's described in the next section.

◀ B&W posterization can result in large areas of middle gray that contrast well with black and white areas.

◀ The same separations used for a color posterization—discussed in the next section—can give an exciting result.

73

Color Posterization

With this technique, you can make striking color images composed of distinct areas of color. You do this by exposing color paper to different colors of light through various combinations of high-contrast b&w negatives and positives. You'll need a set of positive separations and a complementary set of negative separations, all produced from one original b&w negative. You can make the positives as described in the preceding chapter.

To make the complementary set of negatives, contact print the three positives. First make an exposure test to find the minimum exposure to give a dense black image through the clear areas of a positive. This will be your standard exposure for all three contact prints.

Then contact print each of your positives on separate sheets of litho film. Register all of them with the punch-register system. Process the exposed litho films in

the usual way. The dry sheets are negative separations.

It's wise to number your positive separations 1, 2, 3 and so on; and label the complementary negatives 1A, 2A, 3A. You can do this on the edge of the film outside of the image area.

POSTERIZED COLOR PRINTS

The number of colors in a posterized print is determined by the number of pairs

► A basic filtration of 100Y and 10M was used in the color enlarger. This balanced for the color sensitivity of the color negative paper to give neutral tones. For the posterized colors, other color filters were used. The first litho negative separation (1A) was printed on the paper with a strong yellow gelatin filter in front of the lens. This created the violet color in the image.

► The first positive separation (1) and the second negative separation (2A) were combined in register and printed with a green filter in front of the lens. This produced the magenta image.

► The second positive separation (2) and the third negative separation (3A) were combined in register and printed with a red filter to produce this green image.

► The third positive separation (3) provided the background color. In this example, it was printed using a blue filter to produce a yellow color.

Far right: By making the four exposures described onto one piece of paper, the photographer made this dazzling color print.

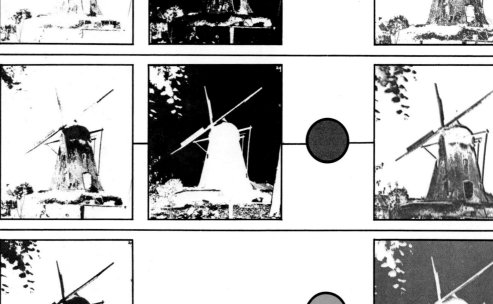

of negatives and positives you derive from your original negative. Pairs are needed so that, when you've made an exposure through one member of a pair, its *complementary* image can be used as a *mask* to protect the already-exposed area during the second exposure.

You can make color posterizations on either color negative or color reversal paper. To produce pure colors, use strongly colored gelatin filters under the enlarg-

◄ Think carefully about the colors you want when posterizing portraits. In this example, the green and yellow face produced a very sinister result. Photo by Lawrence Lawry.

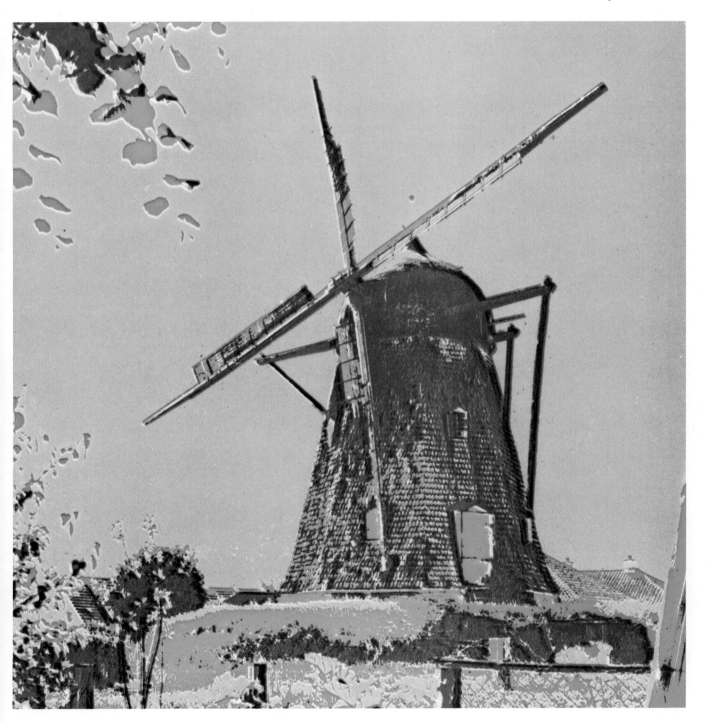

◄ One way to create a variation on posterization is to make a set of positive separations from a color negative. Then print one of these positives in register with the color negative.

► Posterized colors have their strongest impact when used with simple shapes. The choice of filters is also important. By selecting this discordant color combination, Heino Juhanson created a powerful graphic.

▼ Not all posterized color images are dramatic. Here, making the duck a bright yellow shape against blue water gave an amusing image. Photo by Fred Dustin.

ing lens during exposure. Gels used for theatrical lighting are good—they're inexpensive and come in a suitable range of colors.

MAKING THE EXPOSURE

It's best to make your first color posterization a test—using only one pair of masks. Position the registration board on the enlarger baseboard. Turn out the light and cut a piece of color printing paper to the approximate size of the registration board. Punch two registration holes in the paper and fit it on the registration board, emulsion side up.

Place one of your masks—for example, mask 2—emulsion down on the paper and cover it with a sheet of glass. Put the first filter under the enlarger lens and make an exposure test strip. Remove the first mask and place its complementary mask—in this case mask 2A—on the registration board over the paper. Cover with glass, put a different filter under the lens, and make another series of test exposures. Process the paper normally.

The processed test will show you how to expose to produce the most pleasing densities for the colors involved. You won't have to correct for color balance, because the effects of the gelatin filters are artificial and don't represent reality.

To produce the final print, repeat the sequence, giving the selected exposures through each of your masks with the appropriate filter under the lens. When you've mastered the basic technique, you can try sequences that involve more than one pair of masks. The elaborate images you can produce will be limited only by your imagination and experience.

Starting Screen Printing

Screen printing is not quick, easy and inexpensive. It's a time-consuming process requiring practice. The materials are not cheap, and you must make or buy several pieces of equipment before you can make your first print. So why bother? The best reason is that you can produce fascinating results with screen printing. You're able to extend your photographic techniques to put your pictures on a variety of surfaces, including fabrics, plastics, and metal, in addition to ordinary paper.

The steps given here are an overview of the techniques. If you want more information, a crafts workshop or art school is a good place to get hands-on experience.

BASIC PROCESS

You first convert your image into a pattern of holes—a *stencil*—which is attached to a fabric mesh support tightly stretched over a frame. You then place the frame on the printing surface and force screen-printing ink or dye through the open parts of the mesh with a squeegee.

Most screen stencils are made by hand rather than by photographic processes, but materials are available that allow you to convert a photograph into a screen stencil. Even the simplest photograph can be very effective when made into a screen print.

You can use any color when printing, including white, gold and silver metallic inks, or fluorescent colors. And when you've made your screen stencil, you can turn out a large number of screened prints.

One important feature of the process is its high contrast—ink will either pass through a screen or it won't. This may or may not be an advantage, depending on the type of picture you want to make. To produce a range of intermediate tones, like in a regular photographs, you have to use some special techniques.

You should have some knowledge of high-contrast printing, tone separations, and contact printing large negatives before you attempt to make screen prints from your photographs. See pages 64 to 73. This knowledge will help you control screen-print contrast and handle some of the necessary materials.

TONE CONTROL

Not all pictures require a range of intermediate tones. High-contrast pictures printed from negatives will look even better in the bright colors that you can produce with screen-printing inks.

One way to produce the impression of tones is to use the tone-separation method

▲ Here's what you'll need to do screen printing: light-sensitive screen film, ink, a flexible knife, paper cups, thinner, a broad squeegee, a screen, a stapler, sticky brown paper tape for masking, paper and a suitable work bench.

commonly known as *posterization,* discussed previously. For example, you can use three different high-contrast separations to make three screens. You print these in turn onto the same sheet of paper. Each image corresponds to a different density gray from the original negative. If you print the screens with three different inks, the result is a color posterization.

MAKING A POSITIVE

A high-contrast image is the best sort to use for your first screen-printing attempt. Choose a simple subject. Complex textures in the original picture can be confusing when converted to black and white.

Enlarge the chosen negative onto a sheet of litho film the same size as your final screen print. Develop film in a tray of Kodalith developer for 2-3/4 minutes at 68F (20C). You can expose and process this film by red safelight. Fix and wash the film normally, then hang it up to dry. Find the correct exposure by making test strips. Shadow areas should be totally opaque, and the highlights should be clear. After drying the film, retouch any pinholes in the black areas, using photo opaque. Use the film to make a screen as described here.

POSTERIZED SCREEN PRINTS

The technique for this is the same as for making positives, except that you must make at least three high-contrast positives, and eventually the same number of printing screens, from each original negative. Expose one positive to record just shadow details, give the second normal exposure, and give the third a long exposure to record highlight details.

MAKING A PHOTO-STENCIL

When you've made your positives for the process, the next step is to make the stencil on the screen. There are two ways you can do this—coat the screen with a special light-sensitive emulsion, or attach an exposed photo-stencil film to the screen.

You must degrease the screen fabric with detergent solution, then rinse it well before coating with emulsion. To use photo-sensitive screen emulsion, such as Rockland SC-12, pour and squeegee the

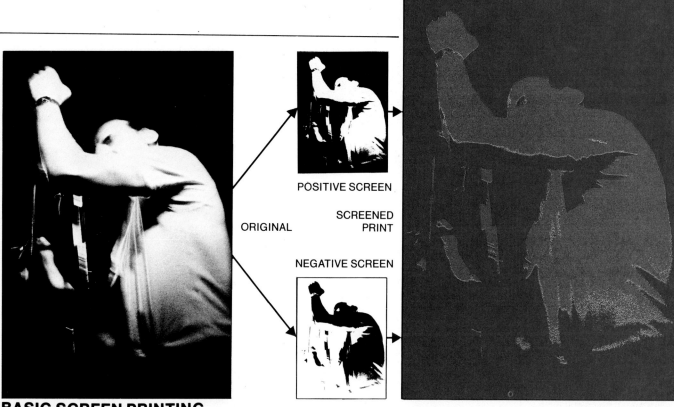

POSITIVE SCREEN

SCREENED
PRINT

ORIGINAL

NEGATIVE SCREEN

BASIC SCREEN PRINTING

First, find a suitable picture with simple, strong shapes. From a negative of the picture, make a high-contrast positive on litho film. Contact print this to make a litho negative.

Make two screens, one from the positive and one from the negative litho images. Then print these two on the same sheet with different colored inks. If the two images don't overlap, the white paper will show through.

PUTTING A PHOTO-STENCIL ON A SCREEN

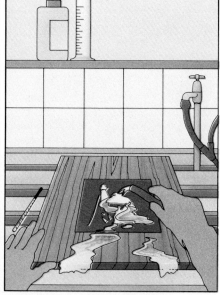

1) EXPOSURE AND PROCESSING

Contact print a photo-stencil film to a high-contrast litho image. After exposure, place the film in hardening solution. Then use a spray of warm water—104F to 113F (40C to 45C)—to wash away exposed areas of the stencil. Be sure to wash the image thoroughly so that fine detail is not obscured.

2) TRANSFER

Transfer the stencil onto the washed and degreased screen. Place the stencil film emulsion down on the wet screen and press it. A raised pad under the screen will allow you to use a roller to press the film down without stretching the screen fabric.

3) DRYING

Blot off surplus water with absorbent paper, then gently dry the screen. Use a fan heater to speed drying, but don't heat the screen above 113F (45C). As the film on the screen dries, the backing sheet gradually bubbles up and can be gently peeled away, leaving the stencil on the screen.

PRINTING THE IMAGE STEP-BY-STEP

Anne Hickmott used four screens to print a multicolored image from an ordinary b&w photograph. She made separations to separate out different densities of the picture. The final result is shown at far right. It was printed in the order indicated below.

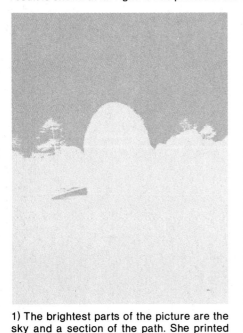

1) The brightest parts of the picture are the sky and a section of the path. She printed these with light-blue ink.

2) Most of the rest of the picture is grass and foliage, so a light-green ink was a good color choice.

3) A more detailed tone separation was printed in another shade of green to add extra richness.

USEFUL TIPS FOR SCREEN PRINTING

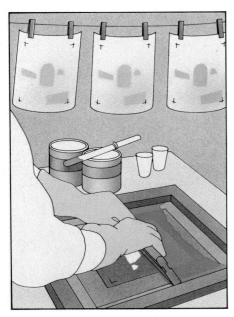

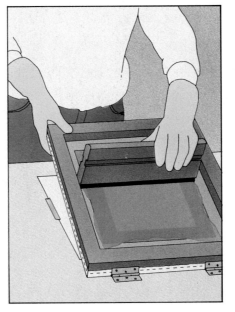

▲ Prepare all of your materials before you begin to make prints. Mix ink to a thin spreading consistency in paper cups, using a palette knife. Dilute with thinner if necessary. Put a sheet of paper under the screen, and pour a line of ink along the top of the image. Then pull the ink toward you over the screen, using a broad squeegee. Do this with a quick, even motion.

▲ The first stroke of the squeegee blade should be sufficient to print your picture. It takes skill, so practice on sheets of cheap paper until you've learned to apply the ink evenly. After you've inked the print, raise the screen and wipe the surplus ink away from you toward the top of the screen. Hang the print on a line to dry.

▲ If you are going to print more than one screen onto the sheet of paper, you must make sure that each coat of ink is registered. Registration marks on each image make this possible. Tape a piece of clear acetate under your screen and print the image onto it. Then use the image on the acetate to line up the prints. Swing the acetate aside before applying the next coat of ink.

▶ The four separate images below left printed in order on one sheet of paper.

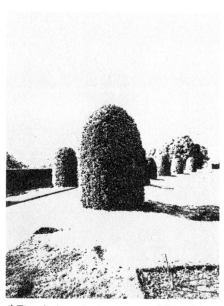

4) The darker shadow areas of the picture were printed in dark brown to add contrast and harmonize with the other colors.

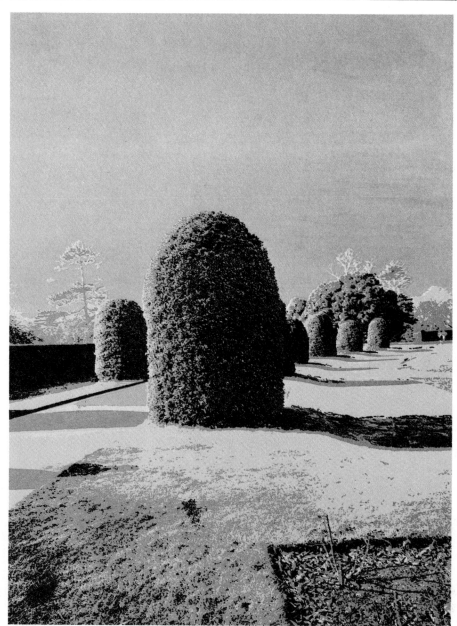

▲ As soon as you've finished making prints, clean the screen. If you let the ink dry on the screen, it will be very difficult to remove. Use screen cleaner or rubbing alcohol applied with rags or paper towels to remove the ink. Rub the screen from both sides simultaneously so you don't stretch or tear the fine screen material.

MAKE YOUR OWN SCREEN

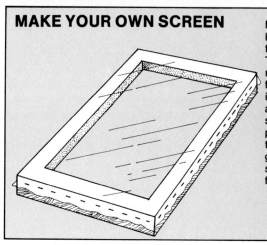

Making a screen takes a little knowledge of carpentry. The frame must be flat and not warp. The type of joint used at the corners is not important. Make the frame big enough—at least four inches larger than the picture area on all sides. Stretch the screen fabric as taut as possible, with the weave parallel to the frame sides. Use a staple gun to tack the fabric in place, stapling from the center of the frame sides outward.

emulsion onto the screen under safelight illumination. With two-part emulsions, mix the emulsion with the sensitizer immediately before use, stir, allow to stand until all bubbles have surfaced.

Place the screen upright and coat it from the underside. After drying the screen in subdued light, apply a second coat of emulsion to ensure that there are no pinholes. When the second coat is dry, you can expose the film.

Exposure—Place the positive film image you've made emulsion down on top of the screen. To ensure good contact between the screen and the film, place the screen on a block of foam rubber or plastic. Put the film on top, and cover with a sheet of glass. You can then make the exposure, using an ultraviolet lamp or bright daylight. Make tests or use the manufacturer's recommendations to determine correct exposure time. Exposure times will be in minutes, not seconds.

Processing—Do it as soon as possible. Because light hardens the light-sensitive emulsion, the unexposed parts of the emulsion—those underneath the opaque black areas of the film positive—remain soluble in water. Soak the screen in lukewarm water for a minute or two and then carefully wash away the unexposed emulsion. Gently blot the screen on both sides and then leave it to dry in a horizontal position. Using a fine brush, you can fill in any small holes and imperfections with sensitized emulsion. When this is done, the screen is ready to use.

To reuse a screen already coated, remove the emulsion with a special decoating agent. This agent, along with all necessary screen supplies, can be obtained at silk-screen or art-supply stores. Wear rubber gloves to protect your hands—the agent is caustic.

Photo-Stencil—The other way to turn your film positive into a stencil is to use *photo-stencil* film. With the light of an ultraviolet lamp or the sun, contact print the positive onto the reverse side of a sheet of photo-stencil film. As is the case with screen emulsion, exposures usually take a few minutes. After exposure, activate the film with hydrogen peroxide to harden the exposed emulsion.

Then wash the unexposed emulsion off with warm water, press the film down onto the underside of the screen, and blot dry with a roller. When the film and screen are completely dry, you can peel off the film support, leaving the exposed, hardened photo-stencil emulsion sticking to the screen to act as a mask. After use,

you can remove the photo-stencil from the screen by softening it with household bleach and scrubbing gently with hot water.

MAKING THE PRINT

With the stencil finally attached to the screen, you're almost ready to make the print. First, apply tape around those areas not covered by the film or emulsion. Use gummed paper tape on the underside of the screen, and around the inside of the frame where it meets the fabric.

If your print is to be made from more than one screen, you'll have to make registration bars. These are strips of cardboard taped to the printing table to help you position the paper or other image-receiving material in the same place relative to the screens.

Mix the ink with an old kitchen knife or a palette knife in a paper cup. Add thinner to the ink until it has a thin syrupy consistency. Work in a well-ventilated area, because screen inks give off odorous and possibly harmful fumes.

Place a sheet of paper under the printing frame, and pour a line of ink along one end of the screen on the inside of the frame. Then, with the frame resting on the paper, draw the ink across the screen with a squeegee. This forces the ink through the screen onto the paper.

You'll need some practice before you obtain perfect results. Don't use too much ink. Hold the squeegee at a 45° angle and draw it toward you. Use even pressure, and don't lift the squeegee until you reach

▲ Kodak Autoscreen is a litho film with a dot pattern built in. It breaks up grays so that they can be reproduced by a screen print. You don't have to make separations for each negative density. With four Autoscreen images printed in yellow, magenta, cyan and black, you can make full-color prints from slides of color negatives. Photo by Anne Hickmott.

▶ You can produce many different looking prints by changing ink colors each time you print. Images by Anne Hickmott.

the end of the screen. Work quickly to print as many sheets as you need before the ink begins to dry on the screen. If the ink does dry on the screen, clean it off with paper towels and alcohol or screen wash.

If you're making a complicated print through more than one screen, you must allow each successive image to dry properly before you print the next layer of ink.

Hang the prints up to dry on a line with clothespins, or spread them out on a table. While the prints are drying, clean up the screen, palette knife and squeegee, using paper towels and alcohol. Ink solvents are very flammable, so stay away from spark or flame while doing this. Store unused ink in screw-topped jars.

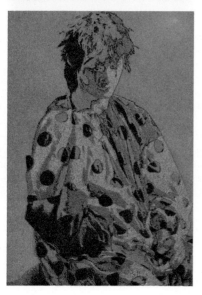

Bas-Reliefs

Combination printing—combining two or more negatives or positives in the darkroom to produce a new image—is a powerful technique. But you need a lot of practice before you can make most combination-printing methods work well for you. It's not easy to hold two or more pieces of film in register in an enlarger, or to predict what the final result will be, until you've had some experience with printing from more than one negative or positive.

However, there is one combination-printing technique that does not require precise image registration or extremely accurate exposure and processing. Therefore, it's an ideal place to start. It's called *bas-relief printing*.

When a sculptor makes a bas-relief, he carves a shallow model of his subject on a flat surface. For example, coins and medals are bas-reliefs. Photographic bas-reliefs look like a picture of a bas-relief carving.

HOW IT WORKS

You can make a bas-relief photograph by sandwiching a negative and a positive image of the same picture together, and enlarging the resulting combination. The secret is that the negative and positive images are aligned but not in perfect register. This also makes the technique simple to do.

If you could make a positive transparency from a negative with exactly the same contrast and density as the original, and combine the two in precise register, the negative and positive images would cancel each other out. You'd get a featureless gray print.

For this reason, your positive copy of the negative must be "imperfect". By combining the positive and negative slightly out of register, you can produce an image with a dark line along one side of each detail and a light line along the edge of the other side. Inbetween, the image is flat and gray.

HOW TO MAKE A BAS-RELIEF

To make the positive transparency, contact print the negative onto Eastman Fine Grain Release Positive film. This is a low-speed, orthochromatic 35mm film that is ideal for making bas-reliefs. It's sold in 100-foot rolls, available through your

▲▶ You can combine a b&w negative with a color slide for an effective variation of the bas-relief effect. Here, Dennis Lane combined his original slide (top) with a high-contrast copy negative to get the result shown at right.

BAS-RELIEFS STEP-BY-STEP

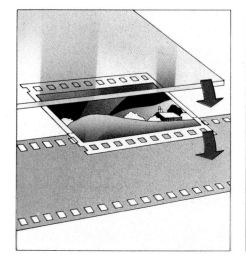

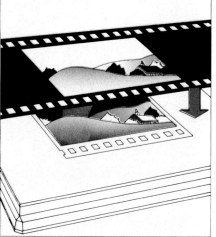

1) EXPOSURE
Make the b&w positive that will be combined with the negative by contact printing it. You can use normal darkroom safelighting, such as that produced by a Kodak OC safelight filter, when handling Eastman Fine Grain Release Positive film. Use a sheet of glass to hold the negative and the unexposed film together. Be sure the glass is clean and free of dust.

2) SANDWICHING
After you've processed the film positive in ordinary print-processing solutions, let it dry in dust-free conditions. When the film is dry, approximately align the two strips of film, emulsion sides facing out.

3) PRINTING
Place the film sandwich in the negative carrier. Place a piece of plain paper in the easel, turn the enlarger on, and carefully adjust the strips of film until the projected image is as you want it. The positive and negative images should be slightly out of register to give the "edge effect." Turn off the enlarger, put a sheet of printing paper in the easel, and make the final print.

▲▶ Ray Daffurn turned this falcon portrait into a very effective bas-relief.

photo dealer. You can treat this film like photographic paper in the darkroom—use the same safelight and print-processing solutions.

When you've obtained the Fine Grain Release Positive film, sort through the negatives you want to convert to bas-reliefs. Good images are simple ones with bold lines. Too much fine detail in the image will produce a blurry, confusing bas-relief. The negatives you choose should have fairly low contrast.

Exposure—To contact print the negative onto the positive film, place it on top of the positive film, emulsion to emulsion, and cover with a sheet of glass. Clean both the glass and the negative very carefully before starting, because it's almost impossible to remove dust specks from a bas-relief print.

Use a strip of positive film that's long enough to stick out of your enlarger's negative carrier on both sides. This lets you make fine alignment changes during printing.

Processing—Process the positive film with processing trays and solutions. You'll have to make several exposures on short strips of film to find the correct exposure time, and it's inconvenient to use film tanks and reels to develop these. Unless you want to keep thse test strips for later mounting and use as b&w slides, you needn't give them more than a brief wash after development and fixing. Speed the drying process by using a hair dryer or a hot-air film dryer.

To make the bas-relief print, place the positive and the negative in the negative carrier back to back. The positive contact print was made with the emulsion sides facing each other. By printing the two pieces of film back to back, you separate the emulsion surfaces by two thicknesses of film base. This allows light to leak around the edges of image details and gives strong lines on the print. Make sure the emulsion side of the negative faces toward the lens when you put the strips of film in the enlarger.

You must position the two pieces of film out of register slightly to produce the bas-relief effect. Make test strips to determine the correct exposure time for the negative/positive sandwich, then make the print in the usual way.

EXTENDING THE POSSIBILITIES

Your final bas-relief print will have a limited range of tones. Most of the image will be a middle gray tone, with white or black outlines around the details of the image. This effect will not suit all subjects. Nonetheless, the basic bas-relief technique is easy to alter to make major or minor changes in many of your photographs.

For example, make your positive with much less density than the negative. The combined effect of the two is to produce a lowered contrast print, rather than one with large gray areas. Then the bas-relief effect will subtly accentuate outlines with-

▲ Alain Choisnet made this picture from an original slide and a high-contrast copy negative. He added a cutout paper moon when converting the bas-relief sandwich into a final, single slide.

▶ To get this effect, Alain Choisnet started with a b&w negative. He made a mostly black bas-relief, and contact printed it to make another negative consisting of mostly clear film. He made the final transparency by duping this through color filters onto slide film. Possibilities with bas-reliefs are endless.

out overwhelming the image.

Alternatively, printing a negative on litho film produces a high-contrast positive that completely masks some areas of the image, leaving others unaffected. How much of the image will be affected depends on the exposure you give the litho film. Litho masks combined with color slides and negatives, contrast reduction by masking in-register, tone separations and many other advanced techniques can be tackled when you've mastered bas-relief.

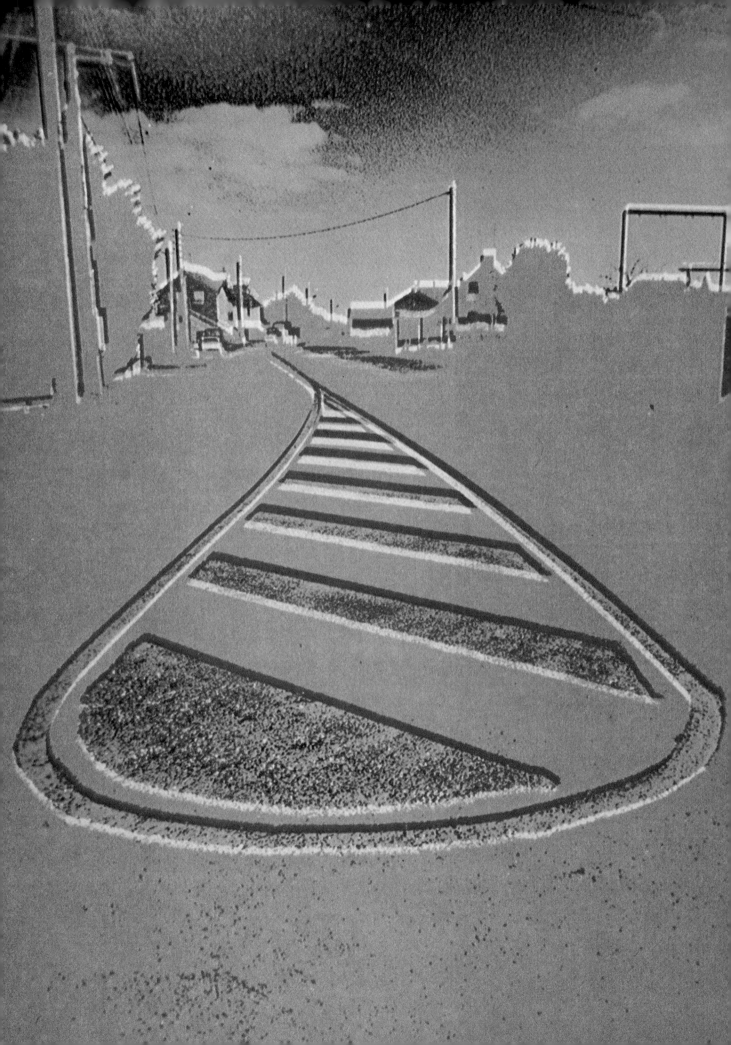

Printing with Paper Negatives

The original negative-to-positive printing process used *paper negatives* exposed in the camera. In the 19th century, it was a difficult process. But today, after nearly 150 years of technological progress, you can easily make similar images in your darkroom.

A positive *transparency,* either color or b&w, is a good starting point. You print the transparency or slide onto b&w photographic paper to produce a paper negative. Then, you use this paper negative to make contact prints, just as you contact print normal negatives.

If you're working from a color slide, the result will not be the same as if you photographed the same subject on b&w film and made a normal print. This is because the response of printing paper to light of different colors is different from the response of normal b&w film. Most b&w papers are orthochromatic—sensitive to blue and green but not to red light—and respond to colors much as the early photographic materials did.

Modern b&w film, on the other hand, is panchromatic—sensitive to all colors. The tone values on the final print will, therefore, be different if paper is used to make a negative from a slide than if normal b&w film were used.

You should take this difference into consideration when choosing slides to print with paper-negatives. Landscapes with a large expanse of blue sky on a color slide will have a disappointingly large expanse of blank white space on the final print. A field of red poppies will turn into a field of black blobs. After you've had some experience with the process, you'll learn to choose the most suitable slides. Remember—reds reproduce black and blues print white.

For your first attempts, choose slides with plenty of sharp detail—subtle, out-of-focus shades of color don't translate well into b&w.

MAKING A PAPER NEGATIVE

Take the slide you've chosen out of its mount and put it into the negative carrier emulsion side up—the opposite of normal. This gives the final print correct orientation when you contact print the paper negative.

Set up and focus the enlarger as usual. Make an exposure test on low- or normal-grade single-weight fiber-base paper. Color slides are usually denser than negatives, and so require more exposure. Make your tests using whole sheets of paper, so you can see how the colors of the

original image translate into a b&w negative. Develop, fix and wash the paper in the usual way. Don't let the print curl as it dries.

WHAT HAPPENS TO COLORS

Blue skies will become black on the paper negative, but by carefully dodging that area when making the paper negative, you can produce a paler gray, which will

print as a gray tone rather than as blank white on the final print. Red will appear as white on the paper negative, and print as black.

Greens will vary according to the original tone and color, but usually produce a medium gray in the final print. Yellows will become dense on the paper negative, and print as pale gray or white.

Sometimes the paper negative itself will

PAPER NEGATIVES STEP-BY-STEP

1) EXPOSING
Place the slide in the enlarger emulsion side up so that the image is reversed. Make your test strips and the final print on low-contrast or normal-grade paper.

2) RETOUCHING
Use a soft pencil to retouch the dry paper negative. It's usually easiest to work on the back.

▲ Anne Hickmott's original photo of this scene has a wide range of tones and presents a detailed picture of the house and water.

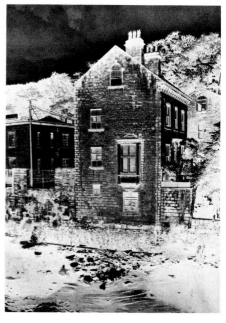

▲ A paper negative made from the slide reverses the tones of the original, while retaining the sharpness of detail in the overall scene.

be interesting enough to be acceptable as a final picture. If so, make two paper negatives, because the printing stage of the process will make the paper negative used unsuitable for display.

MAKING THE PRINT

Having made the paper negative with a range of tones as possible, your next step is to make the paper translucent. This minimizes the texture of the paper base

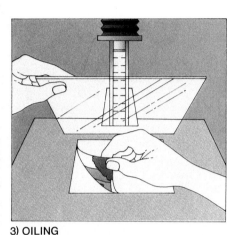

3) OILING
When retouching is completed, rub suntan oil onto the back of the paper negative to make it translucent. Then contact print it on printing paper and process normally.

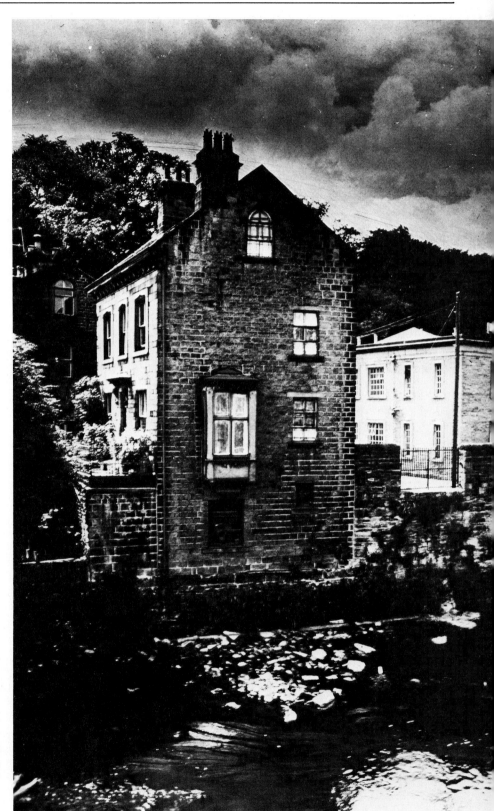

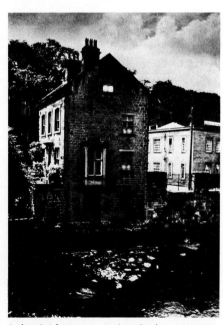

▲ A print from an unretouched paper negative superimposes the texture of the paper negative's base onto the image, giving less detail and coarser tones.

▲ Careful retouching of the back of the paper negative brought out details in the final print and enhanced the mood of the picture. The wall of the house, the chimneys, and areas underneath the eaves have been lightened. Extra pencil work has put lights behind the windows.

and slightly shortens printing times. The best way to do this is to oil the back of the paper before contact printing it. Use colorless suntan oil. It's safe and has a pleasant smell.

Another way is to use water to wet the negative. Soak both the unexposed paper and negative paper. Protect the enlarger baseboard with a sheet of glass. Put the unexposed paper on it emulsion up. Then cover it with the wet paper negative emulsion down. Squeegee the paper negative down. Make the exposure. The advantage of using wet paper is that you don't have to oil the negative to increase its translucency.

MAKING THE FINAL PRINT

Your final prints will usually retain some of the texture of the negative's paper base. The effect is a soft, slightly textured print not unlike a charcoal drawing with broad tones and unsharp edges. This, combined with the orthochromatic rendering of the colors, gives the print an antique quality you can accentuate by brown or sepia toning. Use a matte or semi-matte paper for this effect—highly glossy surfaces look too modern.

RETOUCHING

If you make your paper negative on a matte-surface paper, you can use a soft pencil to retouch the image. For example, telephone wires in the sky of your original slide will appear as white lines on a dark background on the paper negative. You can easily pencil these out on the paper negative.

All alterations to the paper negative will be tonally reversed on the final print, so that added density on the negative will lighten the print. This means you can add detail to shadow areas or remove unwanted detail from midtones and highlights by carefully matching your retouching work to the tones of the paper negative.

▲ The original color slide is practically monochromatic. It was used to make the positive b&w print above. Notice how bluish parts in the original reproduce practically white in positive b&w print. This is because normal b&w printing paper is most sensitive to blue light, making blues reproduce lighter than you'd expect in the print made from a paper negative.

◄ This paper negative was used to make the above b&w print. Because the subject is graphic, the paper negative works well as a picture too. The soft shadows are less obtrusive in negative form, and the plant appears lit from within.

POINTS TO REMEMBER

Make sure that the original slide you choose is suitable. Be particularly careful when choosing portraits—small skin blemishes will be accentuated by the color response of the paper. An imperceptible pink mark can turn into an obvious black spot.

Don't use too contrasty a paper grade for the negative. As with most copying processes, image contrast will increase anyway.

Be sure that the emulsion of the paper negative makes good contact with the final print paper during exposure. Otherwise, some fine detail will be lost in the print. Use a sheet of glass to hold the pieces of paper together.

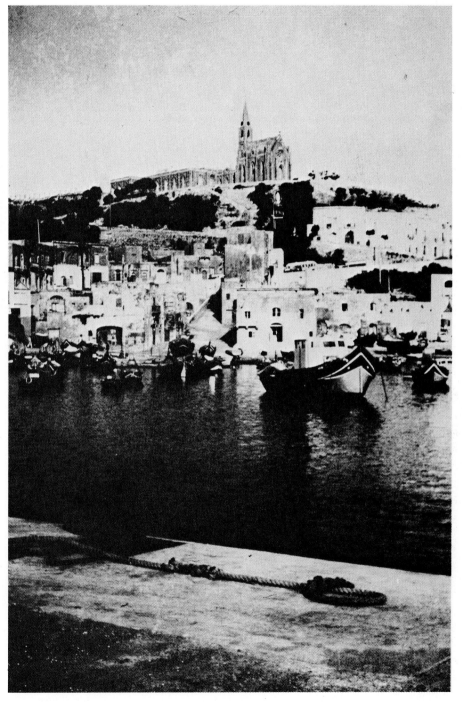

▶ The print made from a paper negative of the above slide by Anne Hickmott gives a completely different effect than the slide. Broad tones and soft details obscure many of the scene's features. Notice how the colors on the boats have changed—the bright bows are almost black, while the dark blue hull is considerably lighter. The blue sky would have lost all tone if the photographer hadn't burned in the upper part of the picture during printing. Sepia toning the print made the print seem even older than it really is. Both negative and positive were made on normal Ilfobrom fiber-base paper.

Using Liquid Emulsions

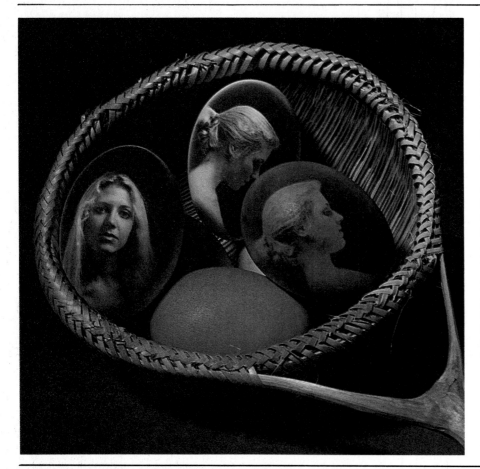

Making photographs on flat sheets of paper is simple. But if you'd like to try something out of the ordinary, it's almost as easy to print your photographs on pieces of wood, stones, mirrors, fabrics and almost anything else you can put under your enlarger. Some non-flat surfaces add an interesting distortion to the shape of the image, too.

THE EMULSION

To do this, you put a light-sensitive emulsion on a surface. Photographic paper manufacturers have large machines that coat a mixture of gelatin and light-sensitive silver compounds onto paper. What the large manufacturers do on a large scale, you can do on a very small scale.

Rockland Liquid Light is a ready-made liquid photographic emulsion that you can paint onto almost any base or surface. It's supplied in small, black bottles as a solidified gel, which liquifies when heated. Also supplied is a *subbing medium,* which you use for coating nonporous surfaces to give

◄ Objects that have been coated with Liquid Light emulsion retain their original color and texture after the surface image is processed. This can enhance the image—notice the sepia look of the picture on the brown egg.

USING LIQUID EMULSIONS STEP-BY-STEP

1) PREPARE YOUR MATERIALS
Melt the emulsion by inverting the tightly stoppered bottle in water at about 122F (50C). Succeeding steps should be under safelight. A hair dryer is useful for warming the surface to be coated because it helps the liquid emulsion flow on easily. Use brushes to apply the emulsion, and also coat some writing paper for test strips.

2) APPLY THE EMULSION
Make sure that normal room lights are off and a printing safelight is on before you open the bottle of emulsion. Apply the emulsion evenly to the surface so the coating has the same thickness on all parts of the object. When the object is coated, leave it to dry in a completely dark place.

3) MAKE THE EXPOSURE
Establish the correct exposure time with the help of the coated-paper test strips. Hold the object in place under the enlarger with a small piece of modeling clay. Stop down the lens for good image sharpness.

the emulsion something to cling to and not slip off during processing. The subbing medium comes in two parts, which must be mixed strictly according to the instructions supplied. If you don't follow the directions carefully, you'll find it very difficult to use the solution.

COATING THE EMULSION

After you've had a bit of practice, coating is a simple process. First, melt a small amount of emulsion. The best way to do this is by turning the tightly stoppered bottle upside down in a beaker of water at about 122F (50C). Immerse only part of the bottle—this way, only the required amount of the emulsion will be melted. When the bottle is opened, the liquified emulsion is at the top. The rest remains as a gel at the bottom of the bottle. If you melt the entire contents of the bottle all at once, lumps may remain in the emulsion when you pour it.

The ideal consistency of melted emulsion is like thin cream. If it's thinner, you'll find it difficult to apply a thin, even coating to the chosen surface. If the coating is too thick, image definition in the final print is reduced. Too thin a coating may also trap air bubbles on the surface. You should use a soft brush to spread the coating over the surface and to remove any air bubbles.

After you've applied the emulsion, tilt the surface of the object you're coating. This spreads the emulsion evenly. It's easiest if you warm the object slightly beforehand—a small hair dryer is a good heat source.

When you coat the material on which you intend to print, also coat a few sheets of paper to use as test strips. Try to coat the test papers to the same thickness and dried in the same way as the material. The

▼ With Rockland Colloid Liquid Light you can put a light-sensitive surface on a variety of different objects. When coating some materials, you may have to specially prepare the surface. Instructions for preparing a variety of materials, from rubber to shells, are included with the bottle of emulsion. A subbing material and antifogging agent are also included.

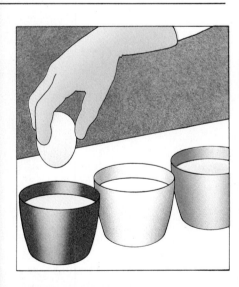

4) DEVELOP THE IMAGE
If the object you're printing on isn't flat, you may have to use bowls to hold the processing chemicals. Or, you can apply developer and fixer with brushes or cotton swabs. Wear rubber gloves to protect your hands when dipping the object. Be careful not to scratch the soft emulsion surface.

thickness of the coating and the amount of heating it undergoes during application affects the final sensitivity of the dry emulsion.

Don't use heat to dry the emulsion. Heat only makes it melt again and spread out further. Put the objects you've coated and the test papers in a dark place and let them dry naturally.

PRINTING AND PROCESSING

Use the coated paper for test strips to find the right exposure. If you're printing on an object that isn't flat, stop down the enlarger lens to increase overall sharpness.

When you've made the exposure, the image can be processed in ordinary print-processing chemicals. If the object you've exposed is not flat, you may need to develop and fix the image in bowls rather than in ordinary processing trays. Or, you can swab the chemicals over the surface with clean pieces of cotton wool. This method uses only small quantities of chemicals, and allows some local control over development. Be sure to fix the image long enough.

With some materials, a stop bath may cause difficulty. For example, if you make a print on an egg shell, you'll find that the

acid in the stop bath will tend to dissolve the shell. In this case, use a plain water rinse between the developer and fixer.

A coat of Liquid Light is very soft when wet, so you must use a hardening fixer to prevent damage to the print surface. Wash the print in cold water—even after fixing. The emusion is still very fragile, and too much heat at any stage of the process can melt the image or make it slide off the object. For the same reason, air-drying without heat is best, even though it may take a long time.

The emulsion is white and opaque before it is fixed. After fixing, it will have

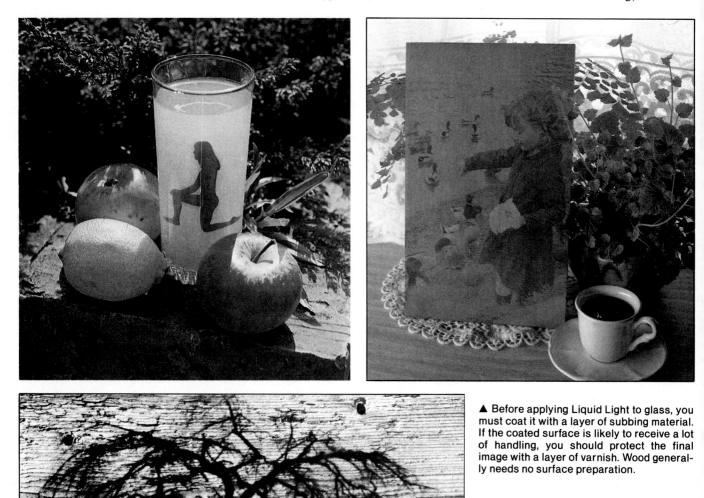

▲ Before applying Liquid Light to glass, you must coat it with a layer of subbing material. If the coated surface is likely to receive a lot of handling, you should protect the final image with a layer of varnish. Wood generally needs no surface preparation.

◄ Consider matching the image to the emulsion-coated surface. Here, a moody silhouette of a tree was given extra impact when printed on wood.

cleared to let the color and texture of the base material show through, with the image superimposed in black. If you wish, you can experiment with further chemical treatments, such as toning to give a colored image, but remember that the emulsion is fragile when wet. It may be damaged by prolonged chemical treatment.

POINTS TO REMEMBER

Always replace the cap on the emulsion bottle after use, and put the bottle back in its box before turning on room lights.

Experiment with different effects that can be achieved during the coating stage. By partially coating only the surface, or by deliberately applying the emulsion with coarse brush strokes, you can create a range of new effects.

You can use surfaces such as glass, metal, wood, light-colored stone, and unusual textured papers as bases for liquid emulsion. The results can be very striking if the image is appropriate to the surface.

▼ For this appealing graphic, a high-contrast litho negative was printed on canvas coated with Liquid Light. Canvas texture shows through clearly. Then the image was hand-colored with transparent paints. Framing added a final touch.

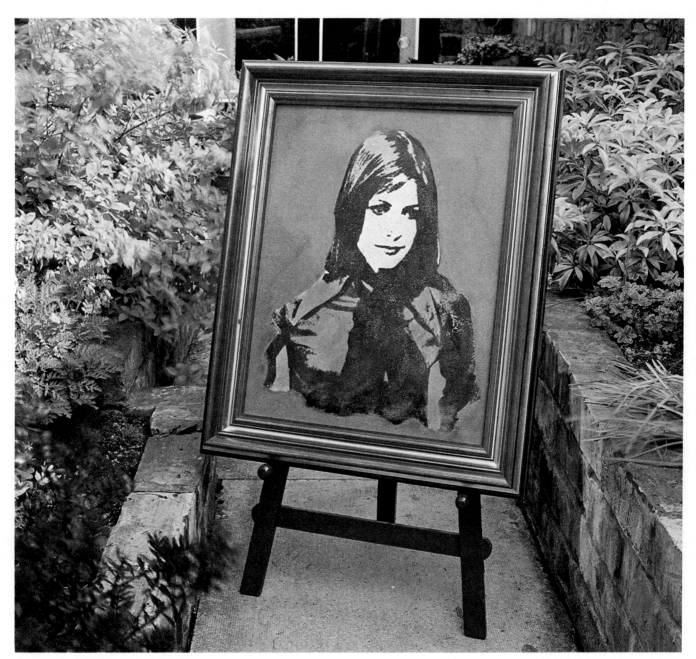

Index

Front Cover Photos:
Windmill by Fred Dustin
Dancer by Amanda Currey
Flower by David Nicholson

Back Cover Photo:
Fred Dustin

8.2133081782